Praise for

Shikake

"Naohiro Matsumura's collection of shikake ideas and theories embodies the timeless Japanese pride in the design of cleverness. . . . The *Shikake* book is a useful shikake itself for planning and creating experiences that can deliver higher customer lifetime value."

— John Maeda, former president of the
Rhode Island School of Design and author of
The Laws of Simplicity: Design, Technology, Business, Life

"Whether you work in marketing, product design, or merely want to delight and inspire your customers and colleagues, Naohiro Matsumura's powerful, inclusive method will show you how to create sustainable behavioral change."

—Nir Eyal, best-selling author of *Hooked:
How to Build Habit-Forming Products and Indistractable:
How to Control Your Attention and Choose Your Life*

Shikake

THE WORLD IS OVERFLOWING WITH SHIKAKE

PROBLEM

Your file boxes are mixed up and you cannot seem to get them in order.

SHIKAKE

Draw a diagonal line.

You will want to put the file boxes back in the correct order to create a straight line.

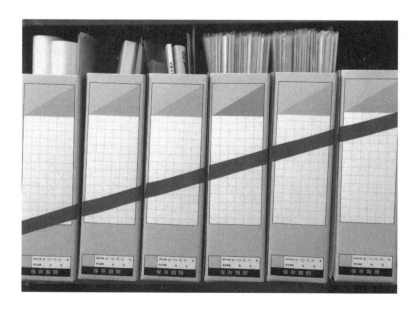

PROBLEM

You want people to use a public urinal cleanly.

SHIKAKE

Add a target to the urinal.

People will want to aim at the target.

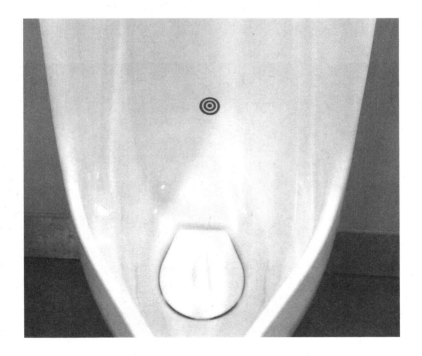

PROBLEM

You do not exercise enough, but climbing stairs is the worst.

SHIKAKE

Make the stairs into a "piano."

You will want to climb the stairs to hear the "piano" play.

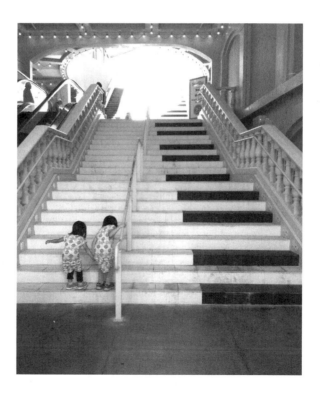

PROBLEM

People are littering.

SHIKAKE

Set up a small *torii*, a symbol that marks the entrance to a shrine, in a public area where littering occurs.

People will now be reluctant to litter.

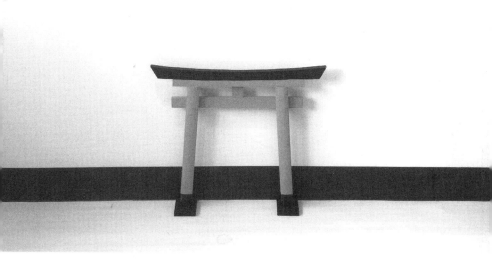

NAOHIRO MATSUMURA

Shikake

The Japanese Art of Shaping
Behavior Through Design

LIVERIGHT PUBLISHING CORPORATION

A Division of W. W. Norton & Company
Independent Publishers Since 1923

SHIKAKEGAKU by Naohiro Matsumura
Copyright © 2016 by Naohiro Matsumura
All rights reserved
Original Japanese edition published by TOYO KEIZAI INC.
English translation copyright © 2021 by Naohiro Matsumura and TOYO KEIZAI INC.

We would like to thank Editage (www.editage.jp) for their support in translating the
original text from Japanese to English.

Image on p. 83 courtesy of Ryo Hiromoto. Image on p. 133 printed with the permission of
the Tourism Bureau of the Australian government and Tadahiro Inoue. All other images
courtesy of Naohiro Matsumura.

All rights reserved
Printed in the United States of America

For information about permission to reproduce selections from this book,
write to Permissions, Liveright Publishing Corporation, a division of
W. W. Norton & Company, Inc., 500 Fifth Avenue, New York, NY 10110

For information about special discounts for bulk purchases, please contact
W. W. Norton Special Sales at specialsales@wwnorton.com or 800-233-4830

Design by Ellen Cipriano
Manufacturing by Lake Book Manufacturing
Production manager: Julia Druskin

Library of Congress Cataloging-in-Publication Data

Names: Matsumura, Naohiro, author.
Title: Shikake : the Japanese art of shaping behavior through design /
 Naohiro Matsumura.
Other titles: Shikakegaku. English
Description: New York : Liveright Publishing Corporation, [2021] |
 Includes bibliographical references.
Identifiers: LCCN 2020035784 | ISBN 9781631497810 (hardcover) |
 ISBN 9781631497834 (epub)
Subjects: LCSH: Design—Psychological aspects. | Persuasion (Psychology)
Classification: LCC NK1520 .M4213 2020 | DDC 745.40952—dc23
LC record available at https://lccn.loc.gov/2020035784

Liveright Publishing Corporation, 500 Fifth Avenue, New York, N.Y. 10110
www.wwnorton.com

W. W. Norton & Company Ltd., 15 Carlisle Street, London W1D 3BS

1 2 3 4 5 6 7 8 9 0

A love letter to my daughters, Hanami and Ichika.

Contents

Shikake

Shikake
in the Wild

The Tube at Tennōji Zoo

I started out as an artificial intelligence researcher studying topics that would be helpful for making data-based decisions using computers. However, one day in 2005, I realized the obvious fact that most of the things in the world were not included in the data we collected.

If you stand still and listen, you can hear the chirping of birds and the rustling of tree leaves. These natural phenomena, which take place right in front of our eyes and ears, were not included in the data we collected. And even the highest-functioning computer is merely a box if it is not fed data.

One response to this realization would be to stop depending on data and computers. By not depending on data and computers, you may become more aware of the inconspicu-

ous blooming of flowers and the chirping of birds along the side of the road. What we need is not data or computers, but *shikake*, things that help make people aware of the space they live in and how they pass through that space.

Shikake are a means through which people become aware of those things that they can see but do not see, or that they can hear but do not hear. Through shikake, spaces outside of the world of computers—that is, the spaces of everyday life—became the objects of my research.

As I began to collect examples of shikake, I realized that they can be used to solve all sorts of problems. This was the origin of the field of *shikakeology*.

I found the tube shown in Shikake 1 in the Asian rainforests area of the Tennōji Zoo in Osaka while on a recreational visit. There was no explanation given for this device, so it was not clear how it could be used. However, since it was about the same shape as a telescope, I guessed that it should be peered into.

Seeing the hole in the middle of the tube, I subconsciously wanted to look into it. Furthermore, as the tube was set up about three feet off the ground, the hole in it was positioned to be directly in front of a child's face. Under such conditions, it would be difficult to pass by without looking

into the tube. I began observing from a slight distance as people strolled by the tube, and I could see that children were looking into it and enjoying the sight of (a well-made replica of) elephant droppings placed at its opposite end.

It is difficult to be conscious of things other than animals when at a zoo. This tube was placed in a remote location adjacent to the elephant area, a place that would have been quickly passed by had the tube not been present. However, because the Tennōji Zoo consists of "ecological displays" that repro-

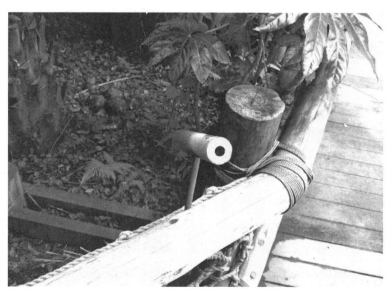

Shikake 1. A viewing tube at a zoo.

duce the environment of an animal's habitat, a variety of sights are available beyond the animals themselves.

The elephant area tube is a shikake: it makes you realize that there are things to see at a zoo other than the animals.

This tube was the first shikake I discovered, and it enabled me to create a method of experiencing the world that was not reliant on data or computers, which I felt were limiting. I realized that it was important to create awareness in people of things that they would not otherwise notice. Designing shikake was an effective means of accomplishing this goal.

Even now, I sometimes make my way to the Tennōji Zoo to confirm that this tube is still there.[1] It has other qualities that are typical of effective shikake—qualities I will discuss—in that it is difficult to break and does not require much if any maintenance due to its simple structure.

After discovering this tube, I visited many different places searching for similar designs and devices. Eventually, I had collected more than one hundred examples.

At this point, I had the opportunity to leave Japan and conduct research at Stanford University, so I endeavored to analyze the examples I had collected to clarify the principles of shikake. This book is based on the results of those efforts.[2]

Solving Problems Through Behavior

Many of the problems we face are created by our own behavior. The problem of a lack of exercise can only be solved by exercising. Getting other people to walk around will not fix your own lack of exercise. Overeating and messiness are similar problems that can only be solved by changing one's own behavior.

Because larger problems, such as environmental issues and automobile accidents, are ultimately made up of aggregated individual behaviors, changing one's own behavior is connected to solving these society-wide matters as well.

A lack of exercise is a personal problem, but as the number of unhealthy people increases, medical fees also accumulate, and society's average medical expenses as a whole increase. Medical fee increases are a serious problem in Japan, which is becoming a super-aged society, in which more than one in five people are sixty-five or older. One of the ways to solve this problem is for each individual person to pursue a healthy lifestyle.

Many people already know which behaviors are preferable. There are few people who do not know that a lack of exercise or eating too many salty foods is bad for

you. However, our bodies are not immediately negatively affected if we do not exercise and if we eat salty foods. As a result, although we may understand these consequences conceptually, it is difficult to win out over our immediate desires.

In such cases, it is clearly ineffective to tell people directly that "you should do this." Instead, shikake aim to solve these problems in a results-oriented way by indirectly nudging people to feel that they "just want to do it."

Methods for Creating Reflexively Tidy People

There are many approaches to solving any problem. Here, let's adopt the familiar example of messiness and think of various approaches to solving it.

A common approach might be to write "Keep This Area Tidy" on a sign and hang it on a wall. However, we know from experience that this kind of sign has almost no effect. If you were willing to tidy things up just because you were told to do so by a sign, then you probably would have tidied up already.

So, let's take a different approach, one involving shikake.

Consider Shikake 2. If we draw a single diagonal line across the spines of a row of file boxes, it becomes easy to identify whether the boxes are lined up in order. If the boxes are out of order, our attention is drawn to the broken line, making us want to correct it, and as a result an organized and tidy state is achieved. The same effect is seen with comic books in which the book spines, when put in the correct order, combine to form a picture, as shown in Shikake 3.

In a bicycle parking lot, if lines are drawn on the pavement, cyclists will feel uneasy parking their bicycles in a way that crosses the lines and will instead park within them. As bicycles parked in a chaotic way not only decrease the number of available spots but also cause trouble for pedestrians, simply drawing some lines can change the way people park. The bicycle parking lot then becomes tidy and orderly.

Shikake 4 shows the bicycle parking lot at the Cup Noodles Museum Osaka Ikeda. Because bicycles are parked along diagonally drawn lines, they do not protrude into pedestrian pathways.

Another example is a children's room strewn with toys. In this case, it is fairly self-evident that simply telling the children to tidy up will have little effect. I understand this well, as the father of elementary school girls. Whether they

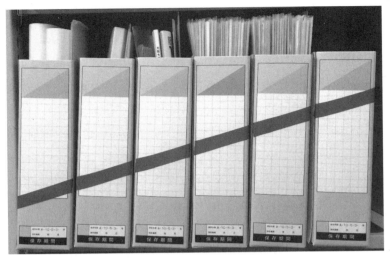

Shikake 2. A diagonal line drawn across the spines of file boxes.

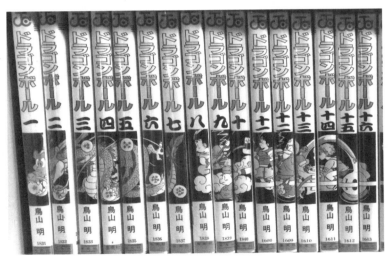

Shikake 3. An image printed across comic book spines.

start to tidy up or not, they inevitably begin to play and always make a mess.

However, by placing a basketball hoop just above a toy bin as in Shikake 5, the children will want to shoot baskets by throwing their toys through the hoop. Although they are playing, the result is that the toys end up neatly stored in the bin.

Shikake 6 shows a stuffed animal called a "Tummy Stuffer" that is sold in the United States.

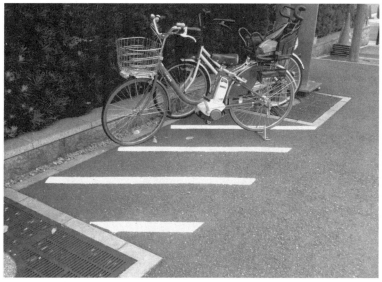

Shikake 4. Diagonal lines drawn in a bicycle parking lot.

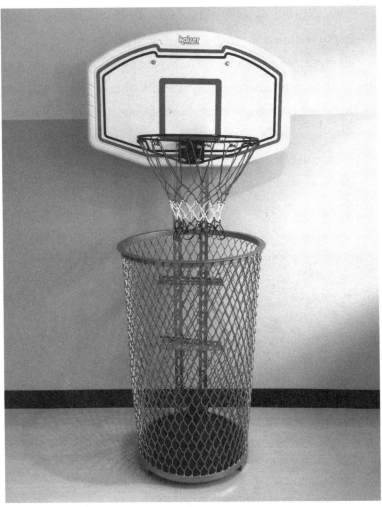

Shikake 5. A garbage bin with a basketball hoop attached.

This stuffed animal has a wide-open mouth and a bag inside for a stomach. If the Tummy Stuffer is put in a children's room and the children are told that "this animal is feeling hungry," then the children will stuff toys into the animal's mouth, which then fill the "stomach," thereby both cleaning up their room and creating a plump stuffed animal.

What about a much larger problem: directing the flow of people in a public space? Because I live in Osaka, I often

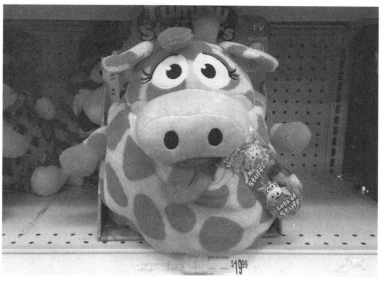

Shikake 6. A stuffed animal collection bag.

fly or ride the bullet train on trips to Tokyo. In Osaka, there is an unspoken rule that you stand on the right side of the escalator and allow people who are in a hurry to pass on the left. However, in Tokyo, the rule is just the opposite: you stand on the left and let people pass on the right. As these rules are very easily confused, I often mistake which side is which. In the process, the lines become disorderly and the flow of people becomes blocked.

In this kind of situation, by painting footprints on one side of an escalator as in Shikake 7, the fact that we should stand on the left side is automatically communicated, and the flow of people becomes more organized naturally. An added benefit is that, as these footprints also show how quickly the escalator is moving, they help prevent people from stumbling.

We can see that even for the familiar problem of keeping things tidy or orderly, there are a variety of approaches, such as drawing lines, setting up basketball hoops, using stuffed animals, and painting footprints.

These are just a few examples of shikake, things that provide us with the opportunity to change our behavior.

What all these particular shikake have in common is

that a state of orderliness is achieved as a result. Although the individual user has no intention of cleaning up, he or she achieves this goal before they even know they are doing so.

From this perspective, it becomes clear that we often engage in such behaviors. Shikake that can change our behavior appear throughout our everyday lives, and they are not just intended to prompt us to clean up for ourselves. Let's now look at the central characteristics of shikake.

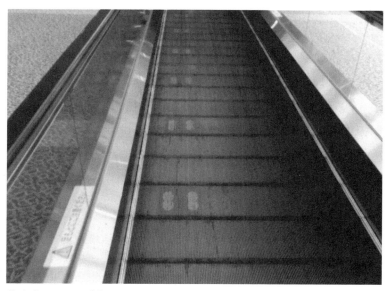

Shikake 7. Painted footprints on an escalator.

The Secret to Changing People's Behavior

How would you go about changing your own behavior? We are not obedient enough to meekly do whatever we are told, and indeed there are times when we want to resist the instructions given to us. Moreover, the sense that even if you do something correctly, nothing will change because the people around you are not cooperating is familiar to everyone.

I am not the only one who thinks about how the desire to have fun is part of human nature, an expression of our individuality, and a human right.

Tom Sawyer, the protagonist in Mark Twain's *The Adventures of Tom Sawyer*, likes to relax. When he is told to paint a fence as a form of punishment, he tricks his friends into painting the fence for him by pretending that he really enjoys painting it, even though he doesn't.

In one of Aesop's fables, "The North Wind and the Sun," the north wind and the sun compete to see who can get a traveler to take off his coat. Although the traveler resists the efforts of the north wind to forcibly blow off his coat and instead wraps it more tightly around himself, the sun encourages the traveler to remove the coat himself by shining brightly on him and warming his body.

The trick to getting people to change their behavior is evident in these stories. The answer does not lie in trying to change someone's behavior directly or forcibly, but rather in inducing them to want to change their behavior themselves without realizing it.

A Urinal Target You Want to Aim At

Shikake 8 shows one of the "targets" attached to the urinals in the men's public bathrooms at Osaka International Airport. Most men (in Japan, at least) have probably seen these targets.[*]

These targets skillfully use our subconsious desire to aim at something. They appeal to our sense of fun and provide a challenge. The target is physically put in a spot that will minimize spray. By aiming at the target, the user unknowingly contributes to keeping the bathroom clean.

One often sees signs on walls that say things like "Please keep the bathroom clean for everyone." However, seeing such a sign does not really compel us to keep the bathroom

[*] The targets themselves are easy to see, but proper conditions for photographing them (i.e., when there are no other people present) and times when they are a suitable subject (i.e., when they are clean) are rare, so obtaining the photograph was quite difficult. The photo of Shikake 8 is therefore a precious item, taken when the toilets happened to have been just cleaned and there were no other people present.

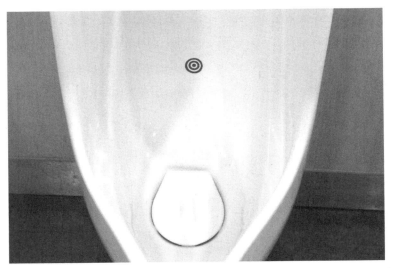

Shikake 8. A urinal target.

clean. Even without the use of such signs, target stickers on urinals are considerably more effective.

In the Schiphol Airport in the Netherlands,[3] "fly" targets have been attached to the urinals in the men's public bathrooms. These targets have been reported to decrease spray by 80 percent.[4] In fact, Schiphol Airport is said to be where the practice of attaching targets to urinals originated.

Aside from "targets" and "flies," there are other variations on these urinal targets. The ones that interested me

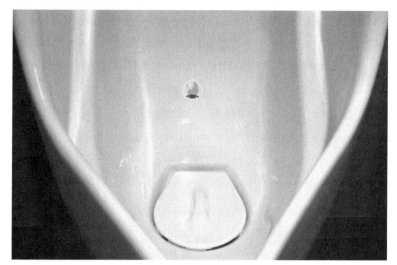

Shikake 9. A "flame" urinal target.

the most are the "flame" stickers attached to the urinals at the Kidzania Koshien theme park, shown in Shikake 9.

The flames are painted using a special paint that changes colors at different temperatures. So, when the flame target is hit, the red color of the flames can be made to disappear as if the flame has been extinguished.[5]

A Staircase and Bin You Want to Listen To

Shikake 10 is a staircase found in Hollywood. By painting black steps in between white steps on the right-hand side, the staircase is made to look like a piano.

Sensors and speakers are installed within each step so that stepping on one causes a musical note to play. This shikake gives people exercise as well as entertainment while going up and down this fun "staircase piano." (The steps are painted on only one side of the staircase so that they do not impede people who are using the stairs.)

Another example of a "sound" shikake is an award-winning work from the Volkswagen company's Fun Theory Contest:[6] "The World's Deepest Bin."

When trash is thrown into this garbage bin, a falling sound can be heard. After continuing for about eight seconds, there occurs the sound of the trash hitting the bottom of the bin.[7]

People want to throw more garbage into the bin so that they can hear the sounds again. In a video of this object uploaded to YouTube,[8] people can be seen going around picking up garbage to throw into the bin.

When a garbage bin with this device was installed in a

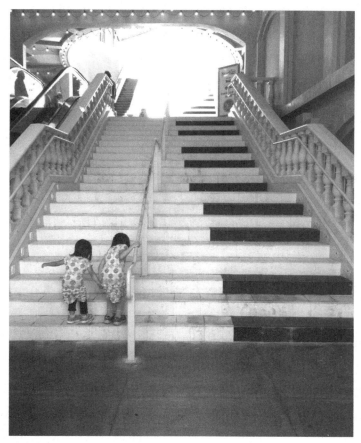

Shikake 10. A piano staircase.

public park, it collected 158 pounds of garbage, or 90 pounds more than a normal garbage bin in a set period of time. Just by using a simple device composed of a falling sound and an impact sound, a breakthrough garbage bin was developed that makes people want to clean up after themselves, and for others, in a public space.

Good Shikake and Bad Shikake

This book provides a summary of research I have conducted on shikake from late 2005 up to the present. It has been written in everyday language for a general audience and does not require any prior knowledge of design, psychology, or any other fields.

However, I would like to clarify in advance a common misunderstanding that I have encountered. This book does not discuss shikake intended to sell products by tricking or deceiving people. The shikake examined here are those that delight users by directing them to act in certain ways without even realizing it.

Shikake can be misused. There may be some people

who have gotten this book looking to profit materially from these shikake. That may be possible, but this book does not hypothesize about shikake that may disadvantage others.

The simplest way to distinguish between "good shikake" and "bad shikake" is this: a good shikake is one where the user has a positive reaction, such as smiling and saying, "Wonderful! It really got me." A bad shikake is one that creates a negative reaction, where the user might feel, "I've been deceived. I won't fall for that again."

Of course, there are many situations in which the distinction between a good shikake and a bad shikake is unclear. Businesses often rotate their best-selling products by changing the way they are shelved or the way menus are written, but this is not a method of deceiving the consumer. If it is done to increase the cost of goods for the customer, then it does disadvantage a group of people. But rearranging things to help get healthy products noticed should not harm anyone. Even if a customer ends up buying something more expensive, if they are satisfied with the purchase, then, in general, they cannot be said to have lost out.

Three Conditions That Define a Shikake

A sense of what distinguishes good shikake from bad shikake is one aspect. However, it is actually more difficult to distinguish between things that qualify as shikake and things that don't.

In this book, shikake are defined as things that cause behaviors that help solve problems and that satisfy what I call the "FAD conditions" (FAD being an acronym made up of the first English letter of the name of each condition):

- Fairness: A shikake does not disadvantage anyone.
- Attractiveness: A shikake invites action.
- Duality of purpose: The maker and the user of the shikake have different goals.

Let me elaborate on each.

The "fairness" condition states that the shikake does not disadvantage anyone. A shikake that disadvantages or deceives any user is considered a bad shikake; in some cases, it should not be seen as a shikake in the first place.

"Attractiveness" is the property of shikake that "invites" action. Things that "force" behavioral changes are excluded

from this definition of shikake. As a requirement for satisfying this condition, a shikake must increase the number of options available to us or invite us to freely choose our own behavior.

In addition, it should be possible to tell that people are choosing certain behaviors because of the attractiveness of a shikake. A shikake that no one notices is not attractive enough.

"Duality of purpose" is the difference between the goal of the shikake maker (the problem they are seeking to solve) and the goal of the shikake user (the reason they want to behave in a certain way). Objects that lack this duality are excluded from this definition of shikake.

In many cases, the real problem that the shikake is addressing is not explicitly stated, and the user acts subconsciously. They simply proceed according to their interests without being aware of the problem their actions will solve. There may be users who realize the relationship between the shikake and the problem, but if the shikake is a good one, then users will not avoid it simply because it is effective.

As with Shikake 4, the lines in the bicycle parking lot, and Shikake 8 and 9, the urinal targets, it is possible to con-

nect self-interested goals with altruistic ones. The user is not aware of the FAD conditions of these shikake, and, indeed, there are many cases in which they will not realize them. However, once you learn how to identify shikake, you begin to notice that you have been living with them all along.

One shikake close to me that I have been using is shown in Shikake 11: the home bread maker.

Before going to bed at night, I put 250g of bread flour, 10g of butter, 17g of sugar, 6g of skim milk, 5g of salt, 180ml of water, and 2.8g of dry yeast into the machine and set the delay timer. Then, when the timer goes off the following morning, I have a freshly baked loaf of bread. Because a wonderful smell accompanies the baked bread, I wake up comfortably, without an alarm clock. Also, since the bread will shrink if not removed from the machine soon after it finishes baking, this motivates me to get up and tend to it even if I feel sleepy. This shikake has exceptional attractiveness, according to the FAD condition of attractiveness laid out above.

Not only am I happy to be able to eat the freshly baked bread as a reward for waking up, but the bread maker also acts as an alarm clock, therefore fulfilling the duality of purpose condition. And, as nobody is hurt by the use of my

Shikake 11. Our home bread maker.

home bread maker, it fulfills the fairness condition as well. Thus it satisfies all of the FAD conditions and can be called a shikake.

A coffee maker with a delay timer produces the same effect. A normal alarm clock that rings and forcibly tries to wake you up is unpleasant, but home bread makers and coffee makers that wake you up in a much more pleasant way are familiar objects that are also shikake.

The term *shikake* has a variety of different meanings in

Japanese. Upon hearing it, some native speakers may think of the stock phrases of a magician who claims that their act has no "tricks or devices," while others may think of a ninja who devises a trap for his foes.

If you look up the meaning of *shikake* in the *Super Daijirin Dictionary* (published in Japan), you will find the following various meanings:

1. To leave something unfinished: "An _____ job."
2. To begin work on something; to set to: "To wait for a partner to _____."
3. To produce something in line with a goal.
 A. Equipment, contrivance, or mechanism: "There are no tricks or _____." "A movie with a _____ that includes an unexpected twist at the end."
 B. In fishing, something that combines a main thread, snell, hook, sinker, and so on to catch a certain type of fish.
 C. An abbreviation for "fireworks piece."
4. An abbreviation for a type of robe worn over a kimono: "The _____ is worn like this."
5. Way of doing; tactic: "They both followed this excellent _____."

6. Deception: "He made money through ____."
7. Preparation; arrangements. In particular, preparations for meals: "The morning ____ had to be done."

The shikake that are the subject of this book are close to definitions 2 and 3 above. However, the shikake I discuss increase the number of choices for our behavior and invite people to subconsciously make certain choices. Also, they do not involve actively working on other tasks, such as in definition 2. Definition 3 does not really fit, since the shikake in this book are objects meant to solve problems using human behavior. The objects themselves do not solve problems. Definitions 1, 4, 5, 6, and 7 have no relationship to the shikake in this book and are completely unrelated to the conditions of "duality of purpose" and "fairness." Following the FAD conditions set out above, the shikake in this book expand on the older Japanese definitions of *shikake*.

Given that I am working in shikakeology as a field of study, I should really use a strictly defined technical term in order to prevent ambiguous interpretations. However, the reason for choosing the Japanese word for "device" was that it was a familiar word to the layman. I would like to use this

book to spread an understanding of shikake that fulfill the FAD conditions to all people.

Where Shikake Can Play an Active Role

As shikake are devices that can solve everything from common individual problems to the larger problems of society, this book is targeted at all kinds of people. A few examples are provided below.

> People who have difficulty waking up.
> Shikake that allow you to wake up comfortably.

> People who are concerned about their physical bodies.
> Shikake that make you want to exercise and dissuade you from eating too much.

> Marketers thinking about storefront promotions for new products.
> Shikake that create interest in a product and get it into customers' hands.

People who work with public policy and are looking for ways to improve unsanitary environments.

Shikake in the form of bins that make people want to throw away garbage and shikake that make people want to wash their hands.

Elementary school students thinking about independent research projects over summer vacation.

Shikake that make children want to help with chores and to clean up their rooms.

These are only a few examples, but I hope they will provide ideas about the ability of shikake to respond to the goals of the reader in a variety of cases, from children to adults and from the home to the business world.

The Fundamentals of Shikake

Increasing Choices for Behavior

One of the primary qualities of shikake is that they often increase the number of possible behaviors for the user. If these newly suggested behaviors are charming or inviting, people will change how they act and will choose these behaviors of their own accord. If they do not find the new behaviors appealing, they will continue to act as they always have.

If a diagram of these relationships were to be drawn, it would be similar to what is shown in Figure 1. The advantage of shikake is that they simply increase the number of behaviors available rather than forcing people to act one way or another.

Because shikake add new possible behaviors to situations where they did not exist before, users have no initial

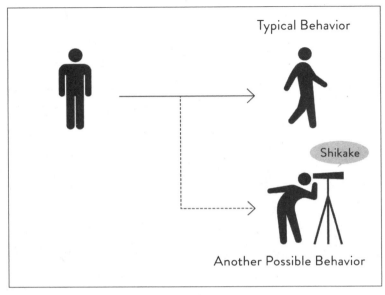

Figure 1. Shikake increase the number of behaviors.

expectations of them. Users then choose on their own how to behave, and so do not become upset because they feel they have been deceived. Thus shikake are a way of resolving problems without disappointing or upsetting anyone.

If we look back at the examples of shikake introduced so far, we can see that shikake implicitly suggest certain behaviors. These include arranging comic books to match the images across their spines, parking bicycles along the lines drawn in parking lots, throwing toys into a basketball hoop

attached to a bin, feeding toys to a stuffed animal, standing on footprints painted on a moving escalator, aiming at a target in a urinal, and waking up to a home bread maker.

You can see that one of the main qualities of these shikake is that all of them get you to choose a behavior by showing it to you in a charming or inviting way.

Skillfully Inducing Behavior

Taking no action is itself a possible behavior and can be the result of a good shikake. Shikake 12, a small *torii*, or shrine gate, is seen near fences or walls in many places in Japan. These *torii* do not serve a formal religious purpose—that is, they are not present because there used to be a shrine in that location or because there is a minor shrine nearby.

These *torii* have been placed in their locations because they encourage people to refrain from inappropriate behavior. Traditionally installed at the entrances to shrines in Japan, *torii* suggest to Japanese people that a space is sacred. If a dog were to attempt to do its business against a *torii* during a walk, its owner would get upset and try to stop it. Used in this way, small *torii* can help reduce the amount of illegal lit-

tering or unwanted behavior that occurs. In such cases, people's actions are constrained through the use of *torii*.

In addition to using a *torii*, it is possible to get people's attention by using signs and posters that read "Littering prohibited" or "Curb your dog." Unfortunately, attempts to forcibly change people's behavior tend to be met with animosity and give people in the area the sense that they are being watched critically. They should therefore be avoided.

Small *torii* are shikake for changing people's behavior while not sending any negative messages.

As the shikakeology approach targets only those people who show an interest in the shikake, we should not assume that it will change everyone's behavior.

When introducing shikake that are appropriate for a given location, we should examine comprehensively not only the effect of the shikake but also its production and maintenance costs, how hard it is to produce, and so on. Even shikake that only affect one person out of one hundred may be good shikake if they can be created simply by putting up some tape.

Although in principle a countless number of behaviors exist, people tend to subconsciously take similar actions each time they visit places they are familiar with. If we thought

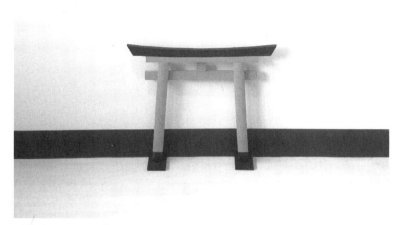

Shikake 12. A small *torii*.

about our actions constantly, we would quickly get worn out and not want to go anywhere.

Accordingly, shikake that do not immediately draw people's attention are often passed by without inviting any interaction. As an example, the tube at the Tennōji Zoo (shown in Shikake 1) is effective because, placed in the elephant area, it draws even the attention of those who only glance at it once.

To draw people's attention, it is first necessary to under-

stand what people are interested in. When creating shikake, we should therefore use the knowledge and experience that we already have. Once we learn the way of thinking that accompanies shikake, the world will begin to look slightly different to us. This will be discussed in more detail in Chapter 2.

"Nudges" provide a theoretical method for designing behaviors.[1] Nudges work on the assumption that people do not always make rational, conscious judgments and that behavior choices should be designed so that no harm is done even if someone makes those choices without thinking deeply about them.

However, shikakeology is not merely design based on the "nudge" theory. We might say that nudges are a way of setting up the action that will always be chosen if one does not think deeply (the default action), whereas shikakeology is a way of setting up another action that people feel compelled to do (an alternative action).

Solving Problems in a Results-Oriented Manner

Regardless of the conscious intentions of the user, problems can be solved as the result of changes to behavior brought about by shikake.

In the example of the urinal target, the user is aiming at the target only because he is interested in hitting a target, but the result is that he contributes to keeping the public bathroom clean.

In this way, when we want someone to act in a particular manner, there are many cases in which it works better to solve the problem in a results-oriented way by connecting that person's interests with their behavior, rather than asking or telling them directly to change their behavior. This is notably effective when the new behavior might be viewed as uninteresting or otherwise unappealing.

In these situations, shikake must be particularly well thought out and well designed. The properties of such shikake are called the shikake's "secondary effect."[2] To phrase this a different way, the shikake approach involves softly "directing"[3] people to solve a problem.

The secondary effect of a shikake is produced by using

the ambiguity of human actions. The ambiguity of actions stems from the fact that the same kind of action can be utilized in different situations. For example, the action of "throwing" occurs when "throwing" balls during ball games as well as when "throwing" garbage into a garbage bin. The secondary effects of shikake can be realized by creating alternative purposes for these combinations of actions and situations.

If a garbage bin is designed to be a basket for tossing balls into and, at the same time, athletic music is played, disposing of garbage quickly transforms into a game. Going a step further, if competition develops between muliple users, the game stops being a boring job and becomes fun and challenging. Even as people are playing, they end up cleaning up the garbage.[4]

Shikake 13 shows the entrance to a school garden in California. This garden can be entered by opening the gate in the metal fence on the left or by crawling through the tunnel on the right. Most children intentionally choose to come and go using the tunnel.

The tunnel shikake relies on the fact that many children will see the tunnel and want to go into it, in the understand-

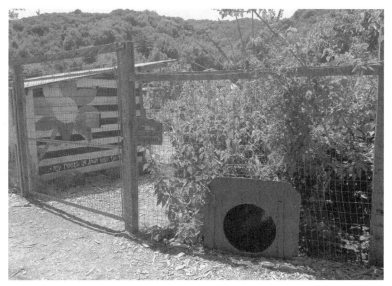
Shikake 13. A tunnel entrance to a school garden.

ing that it will lead to the other side. This shikake skill-fully connects "entering" through the gate with "entering" through the tunnel.

Shikake 14 shows a public collection box (such as might be seen in a shopping center). If a coin is put into one of the sliders in the front or back of the box, the coin goes around and around the conically shaped surface, accelerating before finally dropping into the box through the hole in the cen-

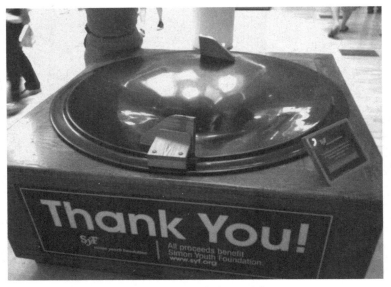

Shikake 14. A collection box with an attached coin slider.

ter. The sight of the coin going around and around and the sound of moving air that it produces are so interesting that a crowd of people often forms around this collection box.

This is another example of substituting actions, in which the act of playing with an unusual machine by "putting in a coin" is subconsciously connected to the act of giving to a public collection box by "putting in a coin."

Shikake 15 is one of the displays of the main Hankyu Department Store in Umeda, which faces a large street.

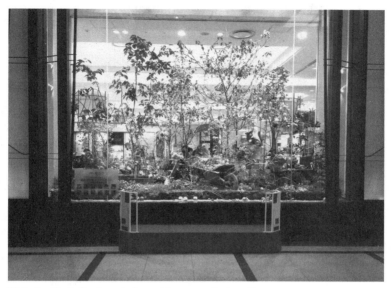

Shikake 15. A display window with an attached podium.

A different design is created and displayed in this window each season.

Even without a stand in front of the window, the displays are very visually appealing and seem to invite the viewer to take a picture. A podium put in front of the display for the viewer to stand on to take a picture magnifies this desire.

Shikake 16 is installed on a large staircase that leads from the third floor of Osaka Station City to Time-Space

Square. In this spot, commemorative photographs featuring trick art can be taken.

Well-taken photographs are things we want to show to others and are thus often uploaded to social media sites such as Facebook and Instagram. These photographs then end up creating publicity for the Hankyu Department Store and for Osaka Station City.

This shikake skillfully combines the action of "wanting to see" interesting photographs and the action of "wanting them to be seen" (wanting publicity).

There are also secondary effects to the secondary effects of shikake. If too much garbage is thrown through the hoop and into the bin, then the overflow will get scattered around. Children who enjoy the tunnel into the garden may do nothing but enter and exit it. People may spend too much of their money watching their coins circle around and around in the machine. Crowds of people taking photographs in front of the trick art may impede the movement of other pedestrians. Thus it is possible for shikake to cause us to get too caught up in the action, actually impeding the desired end goal.

As it is difficult to accurately predict what sort of behavior to expect from the secondary effects of shikake, it is important to make corrections whenever unwanted results occur.

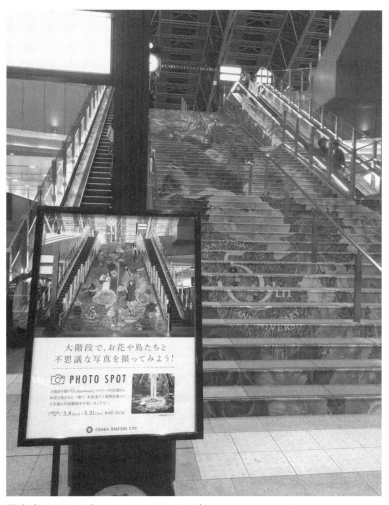

Shikake 16. A trick art commemorative photo spot.

Whether the expected behavior is occurring can be confirmed by behavioral observation. If time or budget allows, it is advisable to conduct a small preliminary experiment beforehand to see if the expected behavior is emerging before setting up the shikake. If the results are not as expected, the shikake needs to be improved. Ultimately, these problems can only be solved through repeated trial and error.

Strong Shikake and Weak Shikake

Some shikake elicit reactions from many people, whereas other shikake may cause only a small number of people to react to them. The strength or weakness of reactions to a shikake can be characterized by the shikake's "benefits" and "costs" to the users.

If the costs required to change one's actions are large, the corresponding benefits will seem unobtainable, and people's actions will not change.

On the other hand, if the costs to change one's actions are small, then it will be easy for people to change their actions even if the benefits obtained are small. It might be said that good shikake impose smaller costs.

Benefits refer to subjective emotional experiences, such as the enjoyment, fun, and sense of achievement provided by a shikake. For example, Shikake 10 produces benefits because the user has an expectation that the piano staircase may make sounds and then gets to enjoy the fact that it actually does. Shikake 8 and 9 provide a sense of achievement from hitting the targets placed in the urinal.

Costs include the physical-, time-, and expense-related costs imposed by a shikake. The cost of a shikake is the additional burden imposed by following or using it.

For example, if the piano staircase is located next to an escalator, then the difference in difficulty between climbing the staircase and using the escalator will be the cost of the shikake.

For a piano staircase installed in a location without an escalator, the costs will be the same whether or not the shikake existed. In this case, the shikake therefore imposes no additional costs at all.

Table 1 shows the reaction strength of a shikake from the point of view of benefits and costs.

The piano staircase imposes significant costs by asking the user to climb the stairs. It would be difficult for this shikake to change the user's behavior if it did not also provide significant benefits by playing musical notes.

BENEFITS			
Feelings of happiness, amusement, etc. caused by a shikake			
	LARGE	SMALL	
COSTS	Somewhat weak	Weak	
Physical-, time-, and	LARGE	(Example: Piano staircase)	(Example: Posters on a staircase)
expense-related costs imposed by	Strong	Somewhat Strong	
the change in behavior	SMALL	(Example: The World's Deepest Bin)	(Example: Urinal targets)

Table 1. The strength of reactions to shikake.

Shikake 17 takes a similar approach, in displaying the number of calories burned on the side of the staircase. This provides a benefit to the user through the sense of achievement gained by burning calories. However, since climbing five stairs burns only about half a calorie, the benefits are not very large. "The World's Deepest Bin" provides significant benefits—above all, the amusement of hearing the sound of a long drop followed by the sound of the impact—but since all you have to do to use it is to throw away a piece of garbage, the costs it imposes are very small.

For the urinal target, the costs imposed by the target in

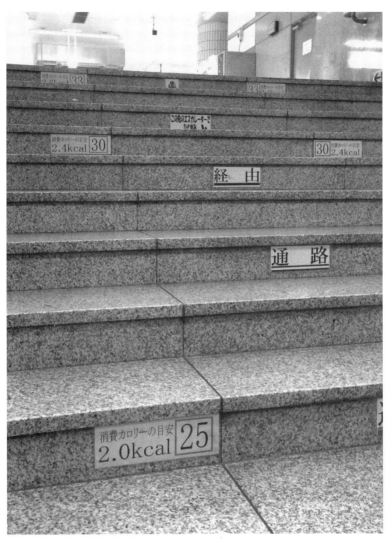

Shikake 17. A staircase showing the number of calories burned.

the urinal are small, but the benefits (the sense of achievement) from hitting the target are also small.

Ranking these shikake by the strength of user reaction results in the following order, from strongest to weakest: "The World's Deepest Bin," urinal targets, the piano staircase, and staircase posters. In general, more people will respond to the stronger shikake than to the weaker ones.

In addition to user benefits and costs, other aspects of shikake are also important. These include the cost of producing the shikake, how difficult the shikake is to produce, the cost of maintaining the shikake, the sustainability of the shikake, and so on. It is not possible to understand all the benefits and costs of shikake simply by comparing their relative strength. However, Table 1 provides a useful reference when thinking about the strength of user reactions to shikake.

The Impact Eventually Fades

I have already described how shikake operate by using aspects of human behavior, but shikake themselves also have a side effect. This side effect is that people get tired of them.

Even if the rarity or impact of a shikake draws people's

interest to begin with, they will start to lose interest in the shikake if they figure out how it works once they have used it. Accordingly, benefits to the user decrease with the frequency with which people interact with a shikake. Because the costs of a shikake do not fundamentally change with the frequency of interaction, it is only possible to change people's behavior as long as the shikake's benefits continue to outweigh its costs. The point at which benefits and costs cross is the junction where the shikake begins to stop changing people's behavior.

Figure 2 shows a general diagram representing this relationship. While benefits and costs are not things that can be measured objectively, the benefit decay curve and the cost line provide a good approach when studying the effect and sustainability of shikake.

The benefit decay curve shows how quickly people get tired of a shikake. The gentler the curve is, the more sustainable the effects of a shikake. Shikake that people find interesting and engage with for long periods of time have gentle decay curves, while shikake that quickly become tiresome have steep decay curves.

It is known in the field of gamification that people get tired of games depending on their ability to get better at them, on whether the game has a suitable level of difficulty,

on whether other people are aware of the game, and on whether the game plays to the user's gambling spirit. These are useful points of reference when thinking about the rate at which people get tired of shikake.

The act of throwing pieces of trash into a garbage bin with a basketball hoop attached to it has a suitable level of difficulty and is also something that people can get better at if they practice. Thus it is a sustainable shikake in this sense. The piano staircase is fun to walk on because it produces musical sounds, but it would be very difficult to perform on it. As a consequence, there is little motivation for the user to engage with it repeatedly. The piano staircase is thus a less sustainable shikake.

Figure 2 shows that a shikake's effect will also be sustainable even if it provides few benefits as long as it imposes low costs. As the costs for the urinal target are sufficiently low, it is easy for the shikake to continue to be effective.

Because the benefits of a shikake decrease over time, only shikake with low costs are ultimately able to continue to be effective for a long period of time. We can also raise the benefit decay curve, making it slope more gently, by adding factors that make it less likely that people will get tired of a shikake.

Shikake 18 is a piggy bank created by my oldest daugh-

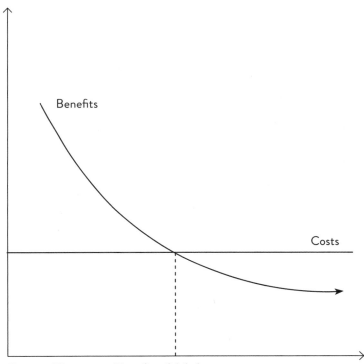

Benefits

Costs

Figure 2. The costs and benefits of shikake.

ter as an independent research project over summer vacation using empty plastic bottles and a plastic case from a dollar store.

Combining a piggy bank with a capsule toy dispenser (which gives out capsules containing toys or cards with something written on them) adds an element of risk and

challenge in an attempt to raise the shikake's benefit decay curve and create a shikake that the user wants to engage with over and over again.

For shikake installed in locations that are not visited often, there is no problem with a shikake only being used once by a user. For tourist locations or event venues, even shikake with higher costs may be enjoyed once if they provide sufficient benefits.

Images of shikake with a considerable impact are easily

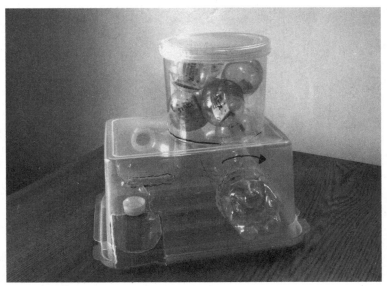

Shikake 18. A piggy bank that dispenses capsule toys.

spread through social media. If people expect to see something that has been publicized at an event or a tourism site, a shikake that provides significant benefits is most suited to the goals of the location, even if the costs are considerable and the sustainability is low.

In other words, though sustainability is an important factor to consider, sustainable shikake are not necessarily the best shikake, or even good shikake.

A Behavior-Focused Approach

Shikake do not attempt to solve problems by using equipment or machines, but rather by using human behavior. This shift in our way of thinking is the core of shikakeology. New approaches to solving problems can be found by switching from an equipment-centered approach to a behavior-centered approach. The notion that it is more convenient to solve problems using equipment because of the possibility of automation is not necessarily true. Installation is necessary, and there are maintenance and repair costs in most cases. The functions of machinery are limited, so there are many cases in which inconvenience is forced on us instead.

For example, it is difficult for a single machine to separate out even one kind of garbage, much less many different kinds. In contrast, if a problem can be solved by changing human behavior, then installation and maintenance costs can be almost entirely eliminated. In addition, the shikake approach can provide a degree of functional flexibility.

There are many cases in which a problem can be solved when humans lend just a little bit of their time.

Keeping public bathrooms clean is a common social problem. Various attempts have been made to solve it. Many have taken equipment-centered approaches, such as self-cleaning urinals and toilets and the development of materials that are difficult to get dirty. However, cost often becomes a prohibitive bottleneck. Conversely, affixing targets to urinals such as in Shikake 8 and 9 is a behavior-centered approach that keeps toilets clean by changing the way people behave.

People littering in inconspicuous places or leaving dog poop behind when taking their dog for a walk are also common problems. The equipment-centered approach involves solutions such as installing motion-activated lights or security cameras that make offenders easier to identify. How-

ever, these are accompanied by often large financial costs, such as paying for the equipment and the electrical wiring involved and monitoring it.

The behavior-centered approach might involve installing a small *torii*, as in Shikake 12, that appeals to social norms that remind us we should not do inappropriate things like littering, particularly in front of a sacred *torii*. This makes it psychologically more difficult for people to litter. A sign showing a person stepping in dog poop might also encourage people to clean up after their pets.

Beware of Pseudo-Shikake

Some objects are intended to function as shikake, but since they do not cause the intended behavior from people, they fail to qualify as true shikake. Pseudo-Shikake 19 is a set of painted footprints that I took a picture of at the Department of Motor Vehicles when I went to renew my driver's license. It can be seen that people actually avoid standing on the footprints.

The footprints implicitly communicate that people

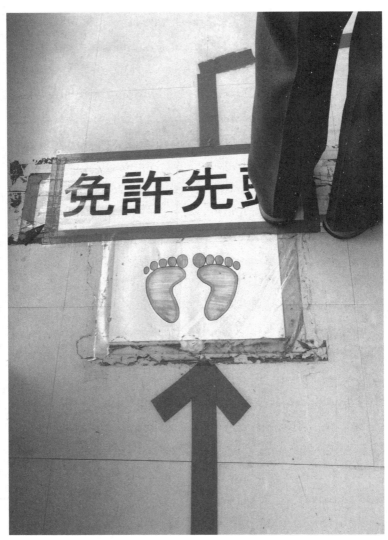

Pseudo-Shikake 19. Hand-drawn footprints.

should stand on them. This kind of shikake is often used successfully on escalators, as in Shikake 7, on station platforms, and in similar places. However, Pseudo-Shikake 19 produces a different result than was originally intended.

Perhaps because these footprints are carefully hand-drawn, people feel awkward about standing on top of them. Since it does not produce the change in behavior it was originally intended to, this example can be called a "pseudo-shikake" and fails to qualify as a true shikake.

Of course, there are, by contrast, shikake that work precisely because people are reluctant to stand on top of hand-drawn images. Tests using posters drawn by children in places such as Osaka and Adachi City have been reported to reduce the incidence of illegal bicycle parking. These posters are processed into sheets and affixed to the surface of roads where bicycles are often illegally parked.

If the footprint shikake at the Department of Motor Vehicles had used an image that did not make people feel uncomfortable about stepping on it, it too would likely have had its intended effect. Perhaps a computer-generated outline of shoes with a sign saying "Your feet here" might be a more successful shikake.

Prescriptions for Atypical Situations

When a person encounters a garbage bin with a basketball hoop attached to it, is intentionally throwing garbage into it from a distance the socially correct approach? Reasonably speaking, throwing garbage from some distance to the garbage can is not very polite. People are unlikely to commend you for it. It would be better to gently toss garbage into the bin from a closer location.

However, since the shikake encourages people by using a basketball hoop, there can be an incentive to "shoot" a basket from a farther distance.

It is well understood that people do not always act according to what is considered correct or proper. Everyone knows that garbage should be thrown into a garbage bin, just as everyone knows that taking the stairs is better for people's health than riding the escalator.

The role of shikake is to invite us to change our behavior by using an approach other than direct command. Shikake are well suited to cases in which we might not adopt behaviors even though we understand that they conform to social norms.

...

SHIKAKE DO NOT EXIST to supersede our understanding of what it means to act appropriately, but rather to suggest an alternative behavior in response to our reluctance to behave in the way that we know is appropriate.

How Shikake Work

The Principles of Shikake

We have already described how shikake are effective as a method for solving problems, but you may not know where to begin if you wish to create a shikake yourself.

Thinking back on my upbringing, I have no memory of learning how to think about or create shikake, despite learning a great many things in a great many places, from kindergarten to graduate school.

However, as shikake draw our attention subconsciously, we can begin to perceive how shikake work when we think about the reasons we are attracted to them.

The urinal target is a shikake that is placed in the right location to make people want to aim at it. When we realize this, we can see that creating something that people will want to use as a target is one method of creating a shikake.

There are many shikake that are as simple as a urinal target, but there are also many shikake that have a more complicated structure. Collecting examples of shikake is a hobby of mine, and I have seen a wide variety of shikake that allow different problems to be solved, are installed in different places, and target users with different attributes or interests.

With so much diversity, it might seem that no underlying principles exist for all shikake. However, the principles of shikake that operate in the background are in fact surprisingly straightforward.

The Elements of Shikake

Before explaining the principles of shikake, I will begin by providing some important terminology for this discussion.

In order to understand shikake in a systematic way, a set of uniform terminology is necessary. For example, when considering the urinal target made to look like a fly, we may immediately think of terms such as "urinal," "fly," and "target."

However, these terms can be used only to explain the specific example of the fly target in the urinal. The principles of shikake explain more general, essential features, not the constituent parts of individual shikake. For example, instead of a fly, a circular target used for target practice or simply the word "target" could also be used. In this sense, "urinal," "target," and "fly" cannot be said to be the essential constituent parts of the principles of shikake.

We need to think not only about describing the essential constituent parts of shikake but also about describing the behavior that shikake elicit.

The term "aim at" precisely expresses the essence of the urinal fly target shikake without referencing any particular target or target design. "Aim at" is much better suited for general purposes and captures the essence of this shikake.

However, this phrase in itself is not necessarily sufficient. Whether it is able to explain many other examples of shikake is also important. We must search for terminology that can be used to explain many examples of shikake and that, furthermore, corresponds to actual examples of shikake.

In this sense, "aim at" is not satisfactory because it is able to explain only a small percentage of shikake.

Generally, terms that express actions (verbs) are not suitable for expressing the principles of shikake because, in the end, they are just too numerous. Because the academic fields related to shikake are wide-ranging, from engineering and design to psychology and behavioral economics, we will use the specialist terminology employed in these fields. I have attempted to create a practical level of abstraction—that is, a degree of conceptual understanding that will allow the student of shikakeology to think about the use and characteristics of shikake in a productive way—while compiling terminology for shikake. By extracting and organizing the characteristics of shikake in this way, the elements of shikake can be narrowed down considerably.

Having investigated 120 examples of shikake, I have discovered that all shikake can be explained through the combination of two different major principles, four different intermediate principles, and sixteen different minor principles. These results are shown in Figure 3. In this chapter, we will examine the details of each principle.

This system is based on classification of specific examples. In other words, it has been worked backward from

these examples, instead of being constructed from theoretical principles.

None of the principles are capable of standing alone, and different classification systems may be possible depending on one's point of view. This classification system should not be understood as the only and absolute system, but rather as one possible way of looking at shikake as a whole.

Major Categories:
Physical and Psychological Triggers

As can be seen by looking at Figure 3, there are two major categories that shikake belong to: those that have physical triggers and those that have psychological triggers.

A "trigger" refers to an "invitation," an "impetus," or an "opportunity." Physical triggers are perceptible physical characteristics that affect a person's actions, while psychological triggers are psychological motivations that a shikake produces within a person. Physical and psychological triggers are related to each other, as shown in Figure 4. The presence of a telescope may impel a person to look through it.

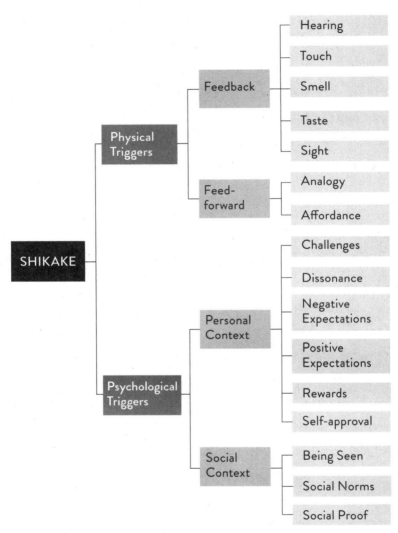

Figure 3. The principles of shikake.

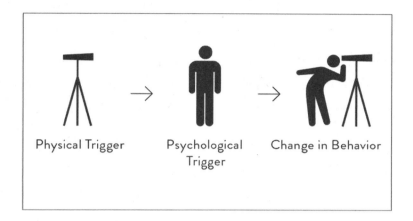

Physical Trigger Psychological Trigger Change in Behavior

Figure 4. A man, a telescope, the man looking into the telescope.

Psychological triggers are brought about by physical triggers. When both types of triggers are connected in a natural way, the shikake can function effectively. "Connected in a natural way" means that the physical trigger causes the user to recall some knowledge or experience. This then leads to the accompanying psychological trigger.

The strength of the psychological trigger, or whether it occurs at all, will vary from one person to another. In some cases, the psychological trigger may not change the person's behavior. However, since shikake do not force us to act in a particular way, an approach in which the user can decide not

to change their behavior is actually preferable. By their very nature, shikake do not work in every case, on every possible person.

With Shikake 10, the piano staircase, that the staircase looks like a piano and produces piano sounds are the physical triggers. The piano staircase causes the psychological trigger of "wanting to play sounds on the piano," thereby producing the behavior of running up and down the staircase.

In Shikake 12, the presence, color, and form of the small *torii* are the physical triggers that produce the psychological trigger of "not wanting to behave inappropriately." This psychological trigger is then connected to the behavior of not littering.

In Shikake 4, the bicycle parking lot, the physical trigger of lines drawn across the pavement produces the psychological trigger of "not wanting to cross the lines," thereby causing people to park their bicycles within the lines.

Shikake function because their physical triggers bring about psychological triggers. These psychological triggers then cause people to change their behavior.

Intermediate Categories: Feedback

Physical triggers, which affect people through physical characteristics, are composed of the intermediate categories of feedback and feedforward.

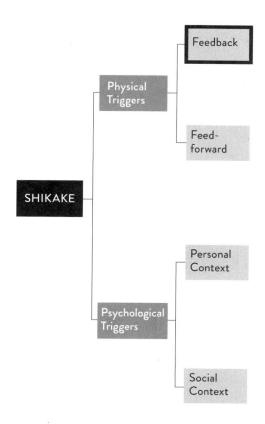

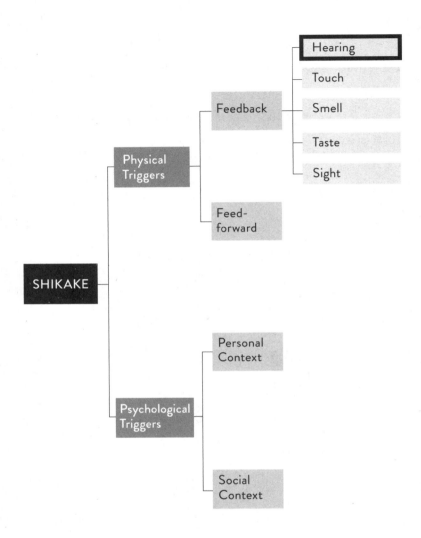

Feedback is how a shikake changes in response to human behavior. Humans perceive these changes using the five senses, so the minor feedback categories are hearing, touch, smell, taste, and sight. We will explore feedforward below.

Minor Category: Hearing
In addition to the visual feedback produced by a coin accelerating as it goes around and around after being inserted into Shikake 14, the collection box, there is also audio feedback in the form of the sound of the air that changes as the period of rotation becomes increasingly faster and the coin circles around and around. This well-designed shikake simultaneously produces both visual and audio feedback.

Shikake 10, the piano staircase, produces audio feedback in the form of the sounds of a piano when people step on it. "The World's Deepest Bin," discussed in the introduction, provides audio feedback, when garbage is thrown into it, in the form of the sound of a long fall and subsequent impact of the garbage.

Certain shikake in Japan have made use of sound since ancient times. An *uguisu-hari no roka,* or "bush warbler

hall," is a hall whose floor makes a creaking sound similar to that of the Japanese bush warbler, thereby making it easy to detect intruders.

Shishiodoshi are bamboo tubes that seesaw back and forth as water spills into them. Water builds up on the lighter side until it hinges forward, making a loud noise by smacking the rock in front of it. The water then spills out of it, after which it rises up again. These shikake are used for scaring away birds and animals.

Wind chimes that play when the wind stirs give us the sense of coolness. These sounds are familiar to us today and are considered elegant. They, too, make use of audio feedback.

Since we often cannot choose whether to hear them or not, sounds can force us to become aware of something. Thus they can form the basis of very strong shikake if they are used properly. However, they can also become a nuisance to those in the area around the shikake if they are used poorly, so the range of places and conditions where these shikake can be installed is limited. Examples of ideal places for sound-based shikake include boisterous events or tourist spots where no one will mind hearing something loud or unusual.

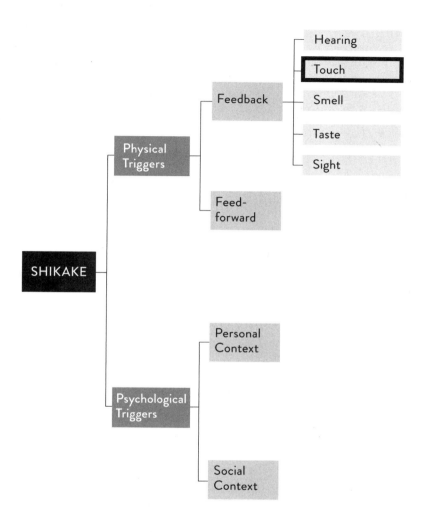

Minor Category: Touch

It is a natural human reaction to want to touch the fluffy fur of a small rabbit or the squishy pads on the paws of cats and dogs. On the other hand, thorny chestnuts look like they would be painful to touch.

Meandering paths often make us want to walk down them. Hot days impel us to seek out cool things, whereas cold days prompt us to find warmth. So, on hot days we prefer walking in the shade, whereas on cold days we want to walk in the sunshine.

These kinds of stimuli, communicated by our hands, our feet, and our skin, shape our behavior. In an actual ad campaign by the company Yamato Transport, the face of a huge black cat (the mascot of the company) was drawn onto an enormous poster several meters in diameter and covered in fluffy black artificial fur. People wanted to touch the fur, which felt pleasurable, and also to communicate their experience to others over social media.

The huge poster was installed at Hankyu Osaka-Umeda Station in Osaka to serve as an advertisement for a news service. Word of mouth made it a topic of conversation and helped the company achieve the desired publicity, just as intended.

There are also shikake that rely on the phenomenon of oscillation. When you use triangular toilet paper rolls like those in Shikake 20, feedback of how much paper you are using is sent to you in the form of three slight oscillations each time the roll rotates.[1]

In comparing the amount of toilet paper consumed when people used these triangular rolls with the amount consumed when they used regular round rolls,[2] we found that the use of triangular toilet paper rolls reduced the use of toilet paper by approximately 30 percent.

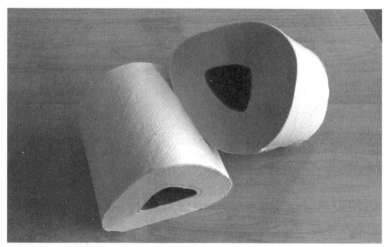

Shikake 20. Triangular toilet paper rolls.

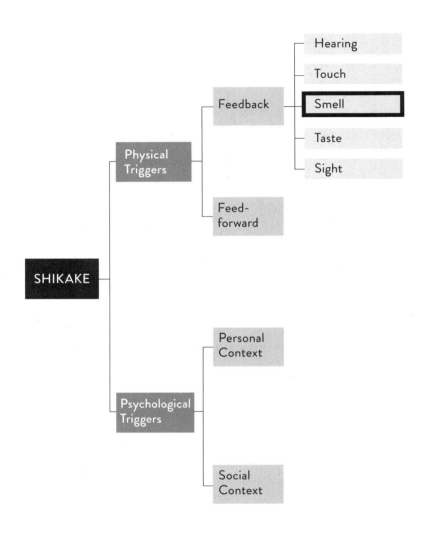

Minor Category: Smell

It is no coincidence that we often encounter delicious smells when passing by storefronts. Shopkeepers produce these smells with pedestrians in mind to alert them to the foods within.

Manufactured scents that smell of freshly baked bread are even sold to bakeries that do not bake their own bread in-house.

Shikake 11, the home bread maker, emits the smell of fresh-baked bread to wake the user up in a pleasant manner.

Shikake 21 is a poster for chocolate candies that makes use of actual scent. Fourteen posters were put up with a sign saying, "Only one of these posters smells like chocolate!" Many passersby sniffed around to find the poster that smelled of chocolate. Since this unique initiative also led users to want to tell others about the experience, it resulted in additional publicity for the company.

Near the entrances to the Kintetsu Nara Line or the Osaka Loop Line at Tsurubashi Station, the smell of *yakiniku* (grilled meat) permeates the air, reaching all the way to the platform and tantalizing riders' appetites.[3] Since I used to switch trains at Tsurubashi Station when I was at the university, an associative memory remains imprinted in my

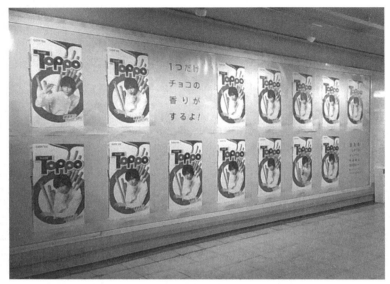

Shikake 21. Chocolate-scented posters.

mind that connects Tsurubashi with *yakiniku*. The result is that, even today, if I decide that I want to eat *yakiniku*, the first thing I think of is Tsurubashi.

Smell, in short, plays a role in a variety of situations and can be used as part of the conception of a shikake. However, smell, like hearing, also compels people nearby into the action, so considerable attention is required when attempting to use these senses in shikake.

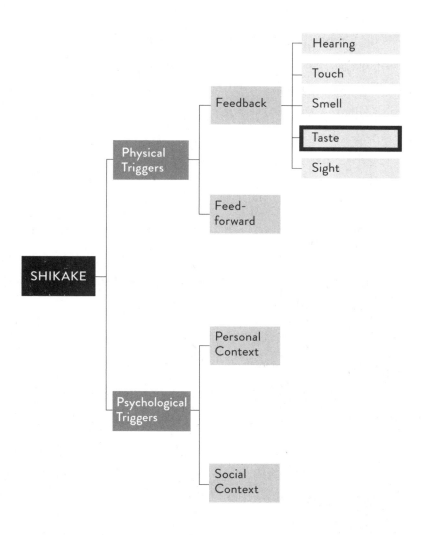

Minor Category: Taste

Shikake 22 is a food-sampling machine for KettlePOP (a popcorn company) seen in an outlet mall in California. Turning the cross-shaped knob underneath the tank releases a handful of popcorn. As with a capsule toy dispenser, we naturally want to turn the knob, an experience that leads us to taste the popcorn and, as a result, remember the taste of the popcorn even in other situations.

Not everything we put into our mouths is food. In

Shikake 22. Food-sampling machines.

Japan, some people stick their parking-lot tickets in their mouths after they receive them at the entrance to the lot, in order to keep their hands on the steering wheel. In one case, a chewing gum company that focused on this unintentional behavior created an advertising campaign for a new flavor by making parking-lot tickets with a layer of mint flavor.

This shikake is based on the taste of the chewing gum. The user encounters the mint taste when they receive a parking-lot ticket and put it in their mouths. This was said to lead to increased sales of the mint-flavored gum at nearby stores.

Small children go through a phase when they want to put everything in their mouths. However, many common objects are choking hazards. To prevent accidental ingestion, a very bitter taste was applied to the Rika-Chan doll. Children found this taste repulsive if they accidentally put it into their mouths. This is a shikake that also makes use of taste to change people's behavior.

Minor Category: Sight
Much of the information that humans receive from their environment arrives visually, so using sight in shikake is a

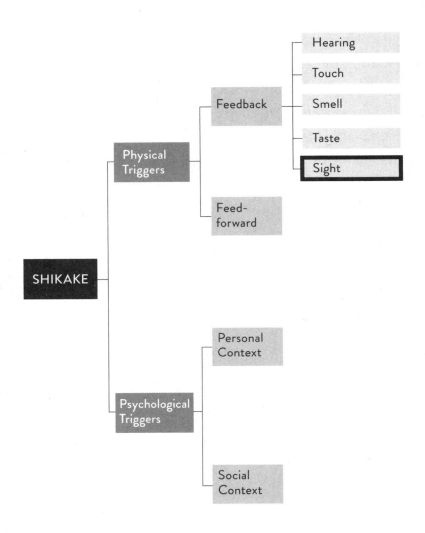

natural approach. Feedback from sight occurs in response to movement, changes in form, changes in color, and so on.

The coin inserted into the collection box in Shikake 14 turns around and around as it accelerates. The stomach of the Tummy Stuffer stuffed animal in Shikake 6 gets bigger and bigger as it "eats" more and more toys. The flame attached to the urinal in Shikake 9 seems to extinguish when it is hit.

Shikake 23 is one of the exhibits installed in the display windows of the main Hankyu Department Store in Umeda, which faces a large street. Cherry blossoms begin to bloom in response to a smiling face being turned toward the mirror. This shikake is sure to bring a smile not only to the user but also to onlookers.

Providing visual feedback in response to a person's actions creates a situation where the user is "playing" with the shikake. This boosts the attractiveness of the shikake considerably.

Sight concerns not only things that are readily visible to the eye; it also concerns invisible things that can become visible.

Pedometers track and show the number of steps we take as a definite number. Seeing that we are taking too few steps

Shikake 23. A display that reacts to a smile.

using the pedometer causes a psychological trigger that makes us want to walk a little bit farther.

The Necomimi,[4] a headband with attached cat ears that move in response to emotions read from a user's brain waves through a sensor, allows us to see the user's emotions, which are normally invisible. The experience of having moving cat ears is fun and therefore produces a psychological trigger that makes the user want to communicate with other people.

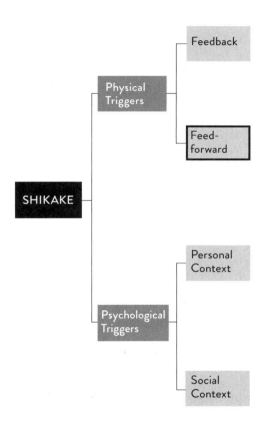

Intermediate Category: Feedforward

Feedforward differs from feedback (a reaction to a person's behavior) in that it is information communicated by a shikake to a person before that person begins to act. A person forms a prediction of what a shikake is used for upon seeing the shikake and changes their behavior as a result.

Minor categories that constitute the feedforward aspect of shikake are analogy and affordance. I will describe both of these below.

Minor Category: Analogy

Analogy refers to the similarity between things. It is used to compare things based on one's knowledge and experience.

The reason that the elephant area tube in Shikake 1 makes us want to peer into it is because we analogize it to a telescope.

The reason that we expect the piano staircase in Shikake 10 to make sounds is because we analogize it to a piano.

The reason that the small *torii* in Shikake 12 leads us to refrain from inappropriate behavior is because we analogize it to the *torii* at a shrine.

The reason that we want to aim at the target in Shikake

8 is because we analogize it to a target on a dartboard or in a video game. We all know, intuitively, to aim at targets.

Furthermore, when the analogy of a flame is added to the urinal target, as in Shikake 9, it produces an effective

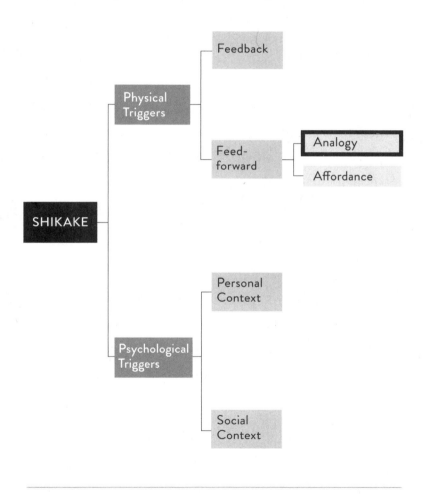

combination of wanting to aim at a target and wanting to extinguish a flame—two effects that work in synergy.

Since analogy transforms something that we are seeing for the first time into something that we are very familiar with (making the strange familiar), it is capable of communicating the desired behavior to people.

Simultaneously, analogies can turn things that are very familiar to us into strange things (making the familiar strange). Many excellent shikake use analogy in this skillful manner, drawing people's interest by simultaneously making the strange familiar and the familiar strange. For example, seeing a flame symbol on a urinal (strange) analogizes into a target (familiar). Through these transformations, they succeed in enticing people to change their behavior.

In the process of discussing shikake in a variety of situations both within Japan and abroad, I have often been asked whether shikake are culturally determined.

Among the more than one hundred examples of shikake I have collected up until now, Shikake 12, the small *torii*, is the only clear example that is specific to Japanese culture. Most shikake are unrelated to culture. (Or, perhaps, in our

globalized world we all share enough of the same culture for this to seem true.) If a universal analogy is skillfully used, it is possible to make a shikake that transcends both culture and nationality.

Minor Category: Affordance

Affordance refers to characteristics of an object that we immediately understand how to use simply by looking at it.[5] According to this definition, it is difficult to distinguish between affordance and analogy. The difference is that affordance refers to characteristics that are able to communicate information even when the user has no prior knowledge (to analogize from).

Even people who have never seen a chair know instinctively that they can sit in it just by looking at the chair. In this case, the chair provides the affordance of "sitting."

Shikake 1, the tube at the Tennōji Zoo, uses analogy in the sense that the tube looks like a telescope, but it uses affordance in the sense that the tube can be peered into because it has a hole and is at exactly the right height for a child. The tube has great attractiveness because it combines these physical triggers.

Affordance implicitly communicates only that an action

is possible. It does not give us the feeling of "wanting to do" something.

A chair affords us to sit, but not everyone will sit in a chair just because they can. We may want to sit in a chair

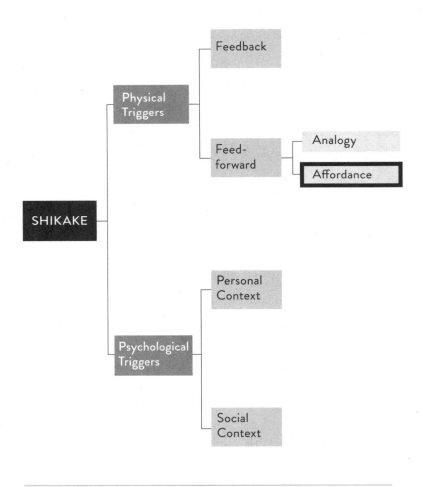

when we are feeling tired or are waiting for someone, but we do not think about wanting to sit in a chair if we are in a hurry.

Affordance alone is not sufficient to make us want to sit. Effective shikake require other factors in addition, such as feedback, which has already been discussed, and psychological triggers, which will be discussed below.

Most of us have a rich variety of experiences and knowledge that allows us to guess how a thing should usually be used. This makes the use of affordance relatively rare. Even with the example of a chair, it is of course far more likely that someone already knows that chairs are for sitting from their own experience!

However, when we encounter a pleasantly firm, flat surface of approximately the right height for sitting, we understand that we can sit there because of affordance. We know that desks are not made for sitting, but we still may sit on them if we are in a classroom that lacks a sufficient number of chairs. The desk affords us the ability to sit.

...

One kind of successful shikake takes inspiration from visual traces. A coating on a floor often begins to peel away in spots where people often walk (as we will discuss further in Photograph 1), and a door often becomes covered

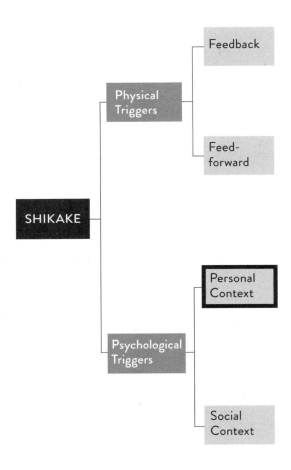

with people's finger marks in the places where the door is often pushed.

Footprints are an abstract expression of the traces of people. The proper way to line up on a platform or at a cash register can therefore be shown simply by painting footprints on the ground.

Shikake 7, the pair of footprints painted on an escalator, is a shikake that uses affordance to implicitly suggest that users should stand on the left side.

Intermediate Category: Personal Context

Psychological triggers are created in people by physical triggers; they are composed of two intermediate categories: personal context and social context.

Personal context refers to a user's personal circumstances. This includes the minor categories of challenges, (the resolution of) dissonance, negative expectations, positive expectations, rewards, and self-approval.

Minor Category: Challenges

Challenges are psychological motivations that make us want to give something a try. The reason that we want to aim at a urinal target or shoot something into a basketball hoop

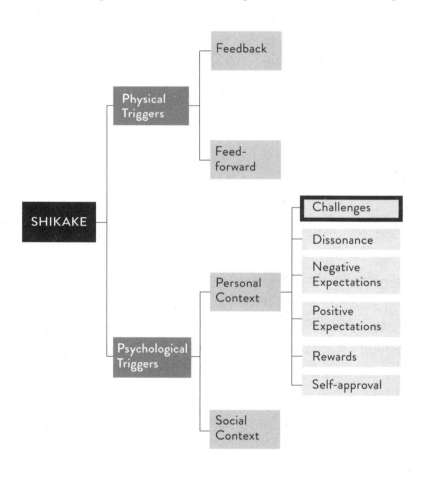

placed over a garbage bin is because these things are challenges that we are compelled to take on.

Since these challenges will not be as enjoyable if they are too easy or too difficult, it is important to set an appropriate level of difficulty. You might want to hit a target that is relatively close to you, but you will probably not enjoy attempting to hit a target that is one hundred yards away.

Adjusting the difficulty level of shikake is often more difficult. Once you have determined what sort of person is being targeted by a shikake, it is important to adjust the level of difficulty so that the target audience can enjoy the shikake.

Many shikake that make use of challenges provide innocent fun but may not produce the desired effects if they are placed in spots where they are overly conspicuous or inappropriate. The garbage bin with a basketball hoop attached will have difficulty achieving its objective in a place where some people might prevent others from playing with it, such as in a church. It is therefore best to install these shikake in settings where they will not draw too much attention or where they will be considered appropriate, such as near basketball courts or at amusement parks.

Minor Category: Dissonance

Dissonance refers to situations where things are disorganized, incomplete, chaotic, or not in their proper place. Situations such as these create psychological motives that

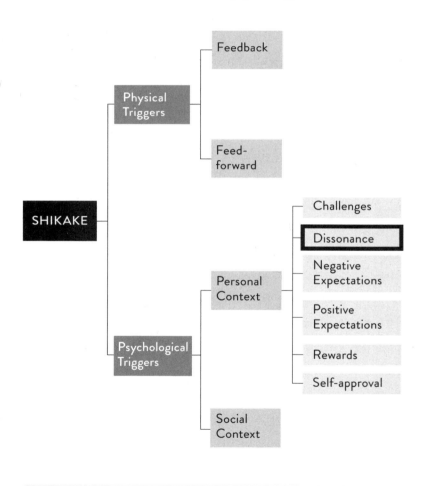

compel us to want to resolve the dissonance. These motives move us to action.

The lines in the parking lot, shown in Shikake 4, make use of dissonance, leveraging the reality that people naturally want to park their bicycles along the lines.

Shikake 2, the diagonal line drawn across the spines of file boxes, relies on the fact that our natural impulse will be to line up the boxes to make the line straight. By making the correct order immediately perceptible, this shikake shows the user how to easily take a cluttered situation and put it in order. In this way, the shikake uses dissonance to accomplish its goal.

Minor Category: Negative Expectations
People seek to prevent as much dangerous behavior as possible, since it makes us anxious and may cause injuries. One of the best ways to prevent dangerous behavior is to make people aware that a given action is in fact dangerous. When people sense danger, they behave in ways to prevent or avoid it. Shikake that are built around these impulses make use of negative expectations.

The camera in Shikake 24 is a mechanism that simply shows a car's speed. When people who are unconsciously

speeding see their speed displayed, they consider the speed limit that they were previously ignoring. If they realize that they are exceeding the speed limit, this shikake makes them want to slow down (in many cases, at least). As we have neg-

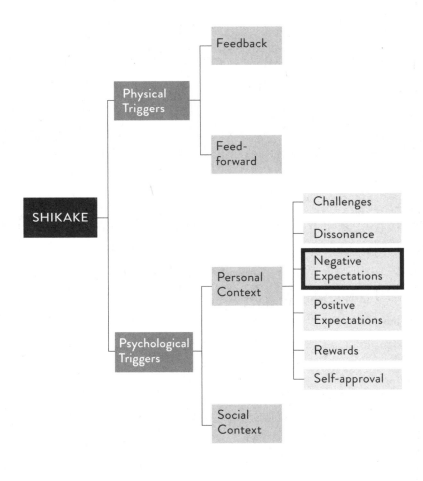

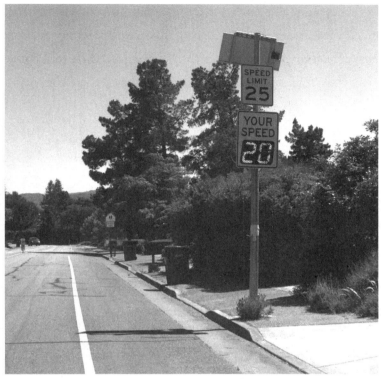

Shikake 24. A speed camera.

ative expectations only for drivers who speed, this shikake works by communicating the fact that a driver is speeding. Some speed signs have red and green lights as well. The red light flashes when a driver is speeding; it changes to green when the driver obeys the speed limit.

Although they are somewhat compulsory in nature, speed bumps can be considered shikake. Speed bumps are very effective at slowing down drivers, but they make the road unusable during genuine emergencies; thus they cannot be installed on roads used by ambulances or police cars. On these roads, an illusion is often used instead. A three-dimensional-looking image of a bump can be painted that makes it seem as if a bump were present. This provides many of the desired effects of an actual speed bump, but it also allows emergency vehicles to pass.

Shikake that operate on these principles[6] can be found on many expressways. Rumble strips produce unpleasant vibrations when they are driven over, letting the driver know that they have crossed out of their lane. These rumble strips also have the benefit of helping to keep the driver alert. Another shikake for increasing safety is known as a shared space. In shared spaces, signals and signs are intentionally removed to make drivers and pedestrians more alert.

All of these shikake make use of negative expectations.

There are a great many examples of such shikake beyond those having to do with safe driving. Restaurants that provide calorie information on their menus encour-

age people who are watching their diet to avoid high-calorie dishes.

A more extreme example: wearing sunglasses with blue-tinted lenses makes food appear blue and tends to decrease

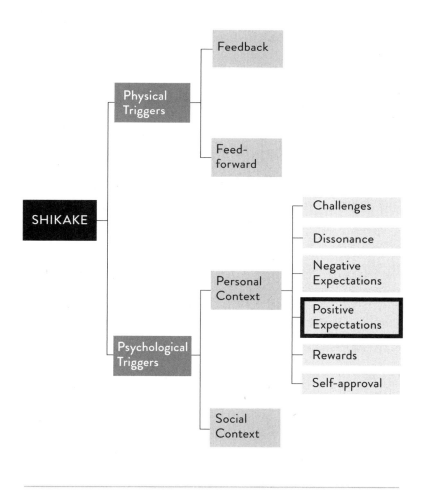

our appetites. This is thought to be because blue food looks like it has gone bad and so causes an instinctive defensive reaction.[7] This shikake also uses negative expectations.

Minor Category: Positive Expectations
Positive expectations, such as being interested in or excited about something, or thinking that it looks fun, are powerful incentives to change behavior. Most of the examples of shikake introduced in this book use positive expectations.

For example, Shikake 1 makes us want to peer into the tube at the zoo because we are interested in what we might see. With the piano staircase in Shikake 10, we want to use that side of the staircase because we expect that it may play musical notes. Shikake 13 makes children want to enter the garden through the tunnel even though entering through the gate is easier. These are only a few examples, but they all make skillful use of positive expectations.

"The World's Deepest Bin," the entry in the Fun Theory Contest discussed in the introduction, uses both a challenge and positive expectations. Many shikake can be designed that use this specific combination.

Minor Category: Rewards

Another method of changing behavior is to provide a reward that makes people happy.

Another entrant in the Fun Theory Contest was the "Speed Camera Rotary." This shikake used cameras to measure the speed of cars and then drew lots to award prize money to one of the drivers who was traveling at exactly the speed limit. It has been reported that the use of this shikake reduced the average speed of cars by 22 percent.[8]

Rewards can be skillfully used to produce a powerful effect, but an opposite effect can also occur depending on the method of giving out rewards. If candy is given to a child as a reward for a well-drawn picture, the child may stop drawing after their next picture if they do not receive candy again. Although the child originally drew because they liked drawing, their objective has shifted from drawing for its own sake to drawing as a means of receiving candy.

This result, in which the use of a reward causes the participant to lose their original motivation, is called the undermining effect.[9] It is necessary to be careful when using rewards. Specifically, it is best to insert an element of uncertainty, in which the user may receive a reward but will not necessarily receive one.

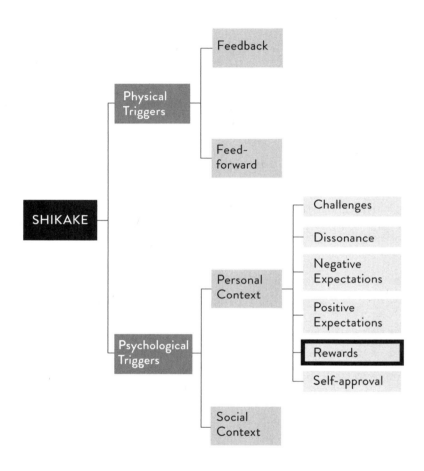

This, in turn, is called the "lottery effect." The "Speed Camera Lottery" does not provide a reward to everyone who drives the exact speed limit, instead making use of the uncertainty of a lottery. It is important to make the user think that they *may* receive an award.

Rewards might seem like positive expectations. The difference is that nothing is given to the user by a shikake that relies on positive expectations. Since the ways of thinking behind these two triggers are distinct, they are treated differently in shikakeology.

Minor Category: Self-approval

Self-approval refers to people's desire to know that their own behavior is logical, reasonable, consistent, and sincere.

Paying attention to our personal appearance is one manifestation of the effect of self-approval. It is because of self-approval that we intrinsically want to check our hair and clothing when we see our reflection in a mirror. Putting a mirror in an elevator lobby makes the time spent waiting for the elevator more engaging. This is likely because we become distracted by our own appearance.[10]

In an experiment that I conducted in one of my classes, I put a mirror at the top of a stand used for distributing

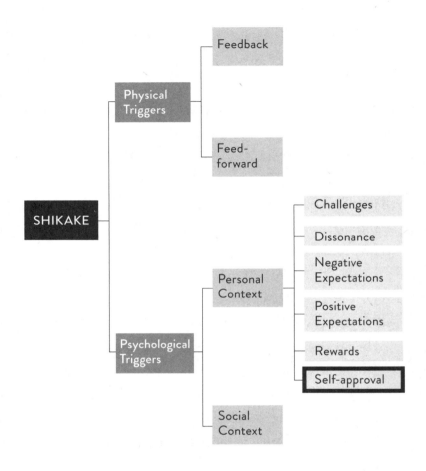

flyers. This device made people look at the mirrored stand 5.2 times more often than at the nonmirrored stand and resulted in 2.5 times as many flyers being taken.

People may come closer to the stand because of their

interest in seeing themselves in the mirror and then take a flyer in order to justify their behavior.

Self-approval is one form of the need for approval. Our desire for external approval might be called, if we were to choose a term, "the recognition of others." Self-approval and the recognition of others are mutually dependent and cannot be easily isolated.

With personal appearance, for example, one aspect of our interest in our own appearance is our awareness of what others see. As a result, this interest cannot be explained by self-approval alone. The recognition of others is deeply connected to social context, the psychological trigger that I will describe next. Since the principles of shikake become somewhat blurry when the recognition of others is introduced, we deal only with self-approval in shikakeology.

Intermediate Category: Social Context

Humans are social creatures and are not easily able to oppose rules that are considered socially preferable. Social context refers to the psychological motivations that bring about these social restrictions. Social context is divided

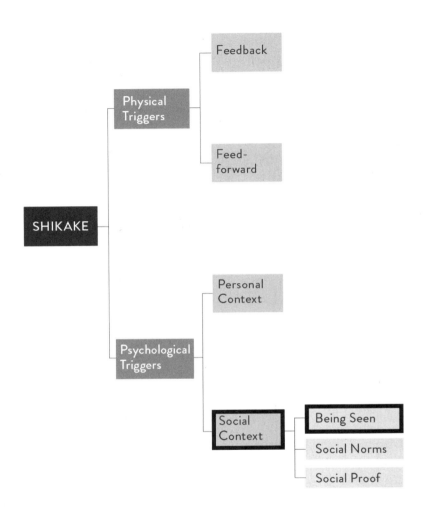

into the minor categories of being seen, social norms, and social proof.

Minor Category: Being Seen
When we sense that we are being watched, we naturally engage in behavior that we believe would not be embarrassing if other people were to notice it. This is called the effect of being seen and is caused by the extrinsic stimulus of another person's gaze.

The most typical approach to making people feel that they are being seen is to draw a set of eyes. Animals may be instinctively aware of sets of eyes so that they know an enemy will attack before the attack occurs.

Starting when we are babies, we make eye contact with other people, as well as with dogs and cats. If we look at cars head-on, their headlights look like eyes and their front grilles look like noses. Cars are intentionally designed like this so that people are more aware of them.

What is interesting is that nobody actually has to be watching us for this effect to occur. A sticker of eyes put on a box for collecting payment for coffee increases the collection rate,[12] while hanging posters with faces on them on the walls of a parking lot causes a decrease in theft.[13]

The graffiti that says "security camera" in Shikake 25 seems to be effective because an inhibiting effect is expected when people are made aware that they are being watched by a security camera.

Minor Category: Social Norms

Social norms are standards that are implicitly agreed upon and that form the foundation for our behavior and judgment.

The small *torii* in Shikake 12 uses the social norm that a *torii* marks a sacred place and that one should therefore refrain from inappropriate behavior in its vicinity.

Likewise, in Shikake 4, when people park their bicycles along the lines drawn across the parking lot, the lines can be seen as using a social norm, because we intrinsically know that we are expected to park within them.

Shikake that rely on social norms may not work when implemented outside of their original context. A shikake that uses a small *torii* will not function in a culture that is unfamiliar with *torii*. Where to stand on an escalator varies between regions, and feet painted in a particular place on an escalator's steps might not make sense in some parts of the world. Removing one's shoes indoors is a social norm that is also culturally determined.

Shikake 25. Graffiti that says "security camera."

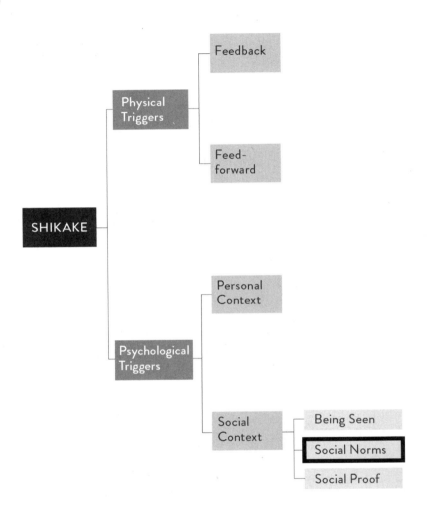

There are countless other examples. In Japan, although it is rude to make slurping sounds when drinking soup, slurping while eating soba noodles is the considerate thing to do. Social norms are often invisible and unspoken, so making them visible through the use of shikake provides an opportunity to change people's behavior.

Minor Category: Social Proof

Social proof is a term for the evidence left by other people's behavior. We use it to navigate the world, and it is key to many shikake.[14]

No one would think that the basket on the front of the scooter shown in Photograph 1 is a garbage bin and should have garbage thrown into it. If, despite this, someone does throw garbage into the basket, the presence of that garbage acts as social proof that the basket may be used as a garbage bin, thereby prompting others to throw their garbage into the basket as well.

When walking around a city, one may encounter musicians playing the guitar and singing with coins or bills in the guitar case opened up in front of them. If the case contains only bills, many people will also place bills in the case, whereas if the case has only coins then many people will also give coins.

The fact that the tips that others have already given has

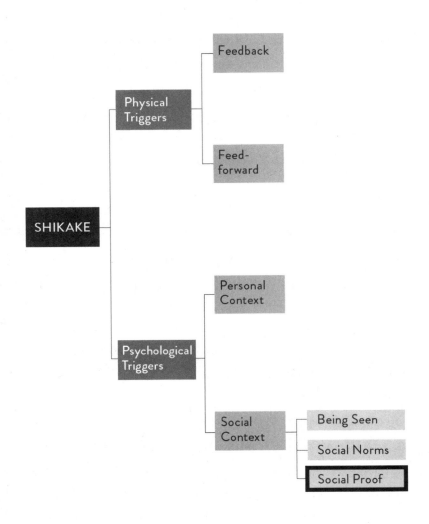

an effect on the amount and form of money a person will give is called the seed money effect. It can be observed in a variety of different situations[15] and is another example of other people's behavior becoming social proof.

In an experiment that my colleagues and I conducted with the cooperation of a convenience store, placing a box for plastic bottle caps on top of a box for collecting plastic bottles increased the rate at which people separated caps from bottles from 49 percent to 60 percent. This may be because

Photograph 1. Garbage in the basket on the front of a scooter.

the first caps placed in the box became social proof, thereby causing more people to separate the caps from the bottles.

Other social proofs include people guessing which restaurants are the most popular based on where lines tend to form, and also people predicting how long it will take for a bus to come from the number of people waiting at the bus stop.

This kind of social proof can be seen in many places in society, and, depending on how the proof is displayed, can prompt people to act in desirable or undesirable ways. The skillful use of social proof to resolve problems is an important approach in creating shikake.

Combining Triggers

Successful shikake reflect the combination of physical and psychological triggers.

I have classified the 120 examples of shikake that I have collected according to the principles they utilize. In addition, I have organized these relationships, as shown in Table 2. The numbers in the inner area of the table show the number of times that physical triggers and psychological triggers are used simultaneously. The more common combinations

may represent more successful shikake, or perhaps shikake that are easier to create.

Table 2 shows thirteen shikake that use both analogy and positive expectations and eleven shikake that use both hearing and positive expectations. These appear to be easy-to-use combinations.

Although there are many combinations that are not used by any of the 120 shikake I have documented, this may be due to the fact that my sample size is too small or that the samples are biased toward conspicuous shikake, rather than because those particular combinations are incompatible.

Still, this sample is useful. Table 2 shows the individual usage trends for each trigger described above. For example, feedback (67 times) and feedforward (71 times) are used in roughly equal proportion, whereas personal context (106 times) is used more often than social context (32 times).

Looking at the table more closely, sight (37 times) and hearing (22 times) make up slightly more than 90 percent of feedback, whereas within feedforward cases, analogy (38 times) and affordance (33 times) are used in roughly the same proportion.

Within personal context, positive expectations (42 times) is the most often used principle at a little over 40 per-

		PHYSICAL TRIGGERS							TOTAL	
		FEEDBACK			FEEDFORWARD					
		Hearing	Touch	Smell	Taste	Sight	Analogy	Affordance		
PSYCHOLOGICAL TRIGGERS	PERSONAL CONTEXT	Challenges	0	0	0	0	9	3	2	14
		Dissonance	4	2	0	0	3	4	5	18
		Negative exp.	1	3	0	0	4	1	6	15
		Positive exp.	11	2	1	0	6	13	9	42
		Rewards	1	0	0	0	4	0	0	5
		Self-approval	2	0	0	0	5	5	0	12
	SOCIAL CONTEXT	Being seen	0	0	0	0	5	5	3	13
		Social norms	0	0	0	0	0	4	0	4
		Social proof	3	0	0	0	1	3	8	15
	PROOF		22	7	1	0	37	38	33	138

Table 2. The relationship between physical and psychological triggers.

cent while, within social context, being seen (13 times) and social proof (15 times) make up over 90 percent of all cases. These usage trends may reflect the ease of use and the size of the effect of different categories.

Table 2, and the trends it shows, can be used as a guide when creating shikake. Commonly used triggers are well suited to less experienced shikake makers, while more experienced shikake makers might endeavor to tackle new combinations. I leave the use of this chart to the reader.

How to Create Shikake

Discovering Shikake

Children Are Shikake Detectors

Children and adults will react differently to a shikake—despite being in the same place at the same time looking at the same shikake—because discovering shikake requires not only knowledge but also curiosity.

When we become adults and our knowledge of the world increases, our curiosity also steadily weakens. As such, if you want to discover shikake—the first step toward creating them—it is a good idea to watch children, who are brimming with curiosity. Children are incredible shikake detectors.

Children are also good at making up problems to solve as a form of play. They will often play by inventing a vari-

ety of arbitrary rules, such as the person who falls off the curb loses, or that you can only step on the white lines when using the crosswalk.

Shikake 26 is a photograph of children playing hopscotch in the shadows of a window frame. Shadows from windows are so common that an adult might not even notice their presence, and the people who designed both the building and the window almost certainly thought only about the window's function as a window. However, if you have the curiosity and creative power to imagine that the shadow of the window frame resembles a hopscotch court, that spot can become a playground at the right times of day.

Adults naturally and subconsciously rely on common sense, thereby missing exciting things that occur right in front of their eyes. If this way of looking can be shifted, then much of the whole world becomes endlessly enjoyable.

I took most of the photographs used in this book, and I took many of these while with my children. This is because observing my children made me aware of the presence of shikake. If you want to discover shikake, I highly recommend observing children.

Shikake 26. Children playing in cast shadows.

Observing Behavior

While observing children is a sure way to find shikake, it is also worth observing adults, even if they are generally less playful and curious. If you watch people sitting in a public space, you will notice which benches are often used, as well as when people sit on things that are not benches but are still comfortable.

If you observe how people use garbage bins in parks, you will realize that the amount and type of garbage differs depending on the location of the bin. If you observe places where bicycles are parked illegally, you will see what sort of person parks their bicycle there and when.

If you turn your attention to people eating their lunches outdoors, you will start to notice where people often eat lunch, who (gender, clothing, etc.) eats lunch where, and what sort of food they eat.

If you observe these kinds of events repeatedly, you will begin to perceive patterns.

There may be patterns related to the number of people passing by, or to the view from a certain seat, or to how people approach and leave the surrounding facilities, or to the

path of sunlight, or to how people use the space to read or to wait for someone.

The knowledge obtained from observing people's behavior in this way can often be used for shikake.

For example, if you, as a shikake creator, want to increase the amount of time that people spend in an open space, it is best to place benches in places where people will want to sit (such as on sidewalks used by people carrying shopping bags) that also face in directions they will prefer. Even without intentionally placing benches in a particular place, people will quickly find places to sit if you simply clean the flat surfaces that are at about waist height.

It is also useful to observe people taking photographs. People take photographs because something has caught their attention, so there may be a clue to some kind of shikake within their line of sight.

When I visited Times Square in New York, people were gathered on the top steps of a large staircase looking at an ordinary advertisement playing on an enormous screen on the Times Square Building. I thought this was odd, but suddenly the image on the screen changed and an image of the people gathered there was displayed instead.

Shikake 27 is a photograph of the huge screen taken at that time.[1] The entire area surrounding Times Square is covered with giant LED advertising boards, so expected and obvious that nobody pays much attention to them. This shikake is an interesting way to draw attention to the board by projecting the people who are in the square.

In recent years, people taking photographs of themselves (selfies) has become a common practice, not only in tourist spots but also in many other places. When taking selfies, it is difficult to get the background into the picture, since your face often takes up a lot of the frame.

Shikake 27. A screen that shows an image of the people watching it.

In response to this problem, the tourism bureau of the Australian government suggested the GIGA Selfie (Shikake 28), a shikake capable of taking a super-high-resolution photograph that shows the entire background. This shikake works by combining approximately 600 photographs taken from a distant location into a single photograph. Showing

Shikake 28. GIGA selfie.

off such a photograph not only lets the viewer see the fascinating Australian scenery but also makes them want to go to that place itself to take a similar picture.

The GIGA Selfie is used to promote Australian tourism and has helped prompt a 118 percent increase in Japanese tourists to Australia (when comparing September 2016 to September 2015, the year the program was implemented).

Observing and reflecting on oneself is called metacognition. There are many cases in which shikake can be discovered by applying metacognition to one's own behavior.

If you apply metacognition to when you leave a building, you may notice that you hesitate to decide which door will open. This may be because the doors lack an important clue.

Photograph 2 shows a manually operated door to the cafeteria at my workplace. Although stickers that say "push" are affixed to both left and right doors, the door on the right side is locked and does not open.

I always attempt to use my right hand to open the door on the right, and of course the door does not budge.

The fact that these doors have "push" written on them tells us that many people mistakenly attempt to pull them open. The reason for this is that the doors have handles. If the handles were removed and replaced with simple push

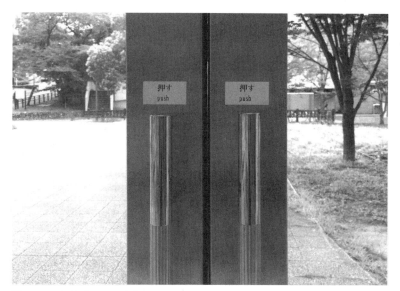

Photograph 2. A manual door.

plates, and if a handprint were drawn on the push plate, then people would intuitively know to push the door.

THE PHYSICAL TRACES of our behavior are also useful for thinking about shikake. The cafeteria floor at my workplace is shown in Photograph 3. If you look closely, you can see that the floor's coating is wearing thin in some places. A pattern can be seen: people turn inward when going around the corner.

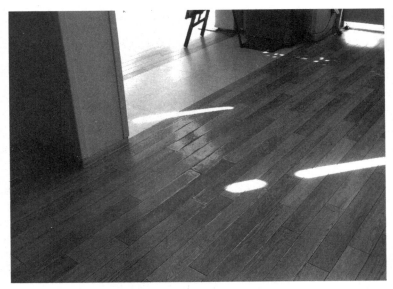

Photograph 3. A well-trodden floor.

Since it is impossible to see people coming from the other direction at this spot, people often walk past each other in a disordered way, even if they don't run into each other. A shikake is needed to improve foot traffic here.

Shikake 29 is a collision preventer installed at a T-shaped intersection at Palo Alto Station in California. Here, as well, the corner creates a blind spot. However, since the edges of the corners of the walls have been lopped off, the blind

spot disappears as you get closer. Being prompted to take a detour around the collision preventer further decreases the blind spot, making it far less likely that collisions will occur.

The world is full of shikake—both intentional and unintentional—but there are also many cases in which shikake go unnoticed.

Observing people's behavior is an excellent way to become aware of the presence of shikake. Behavior can be

Shikake 29. Hallway collision preventers.

observed at any time and in any place. More than anything, though, looking for shikake is fun. I recommend going out sometime and trying to find some interesting shikake for yourself.

Listing and Combining Elements

Among the examples of shikake I have introduced so far, many are simple and easily understandable. However, coming up with an idea for a new shikake on your own is unexpectedly difficult. It is important to start by recalling the FAD conditions discussed in the introduction:

- Fairness
- Attractiveness
- Duality of purpose

Yet as straightforward as these conditions may be, they likely won't allow you to thvink up shikake in a flash. To produce ideas efficiently, it is necessary to learn the best methods for devising ideas for shikake.

I have imagined and created prototype models of shikake that function in a variety of settings, such as event spaces, offices, restaurants, university facilities, zoos, and so on. Below, I will introduce the methods I use to come up with shikake ideas.

When discussing ideas for shikake, we should remember that, fundamentally, "ideas are nothing but combinations of elements that already exist."[2] That is, we can come up with ideas for shikake by listing, drawing inspiration from, and mixing things that we are already interested in.

Table 3 shows the examples of shikake introduced in this book. The targets of the shikake are in the second column, and the third column shows the primary elements that went into making those shikake.

When you look at Table 3, focus on those combinations that appear at first glance to have no relation to each other. By starting with a shikake's target and working backward from there, you may find that highly unexpected combinations can produce a shikake that satisfies both the attractiveness and the duality of purpose conditions of FAD.

...

	SHIKAKE'S NAME	SHIKAKE'S TARGET	SHIKAKE'S ELEMENT
1	Tube	Zoo	Tube
2	Line along folder spine	File folders	Diagonal line
3	Single image along books spines	Comics	Image
4	Lines in bicycle parking lot	Bicycle parking lot	White lines
5	Garbage bin w/basketball hoop	Garbage bin	Basketball hoop
6	Stuffed animal storage bag	Storage bag	Stuffed animal
7	Footprints on moving sidewalk	Moving sidewalk	Footprints
8	Urinal target	Urinal	Target
9	Urinal target	Urinal	Flame target
10	Piano staircase	Path	Piano
11	Our home bread maker	Home bread maker	Timer
12	Small *torii*	Location	*Torii*
13	Tunnel entrance	Entrance	Tunnel
14	Collection Box with coin slider	Collection box	Coin slider
15	Display on a stand	Stairs	Trick art

Table 3. The elements and targets of shikake.

IN MY VIEW, there are at least four methods for creating shikake:

- Repurposing an existing shikake
- Using similarity of behavior
- Starting with the principles of shikake
- Using Osborn's checklist, a well-known brainstorming method

Below, after discussing each of these methods, I will also discuss Maslow's hammer, a rule that one should be aware of when creating shikake.

Repurposing Shikake

The simplest method of thinking of ideas for shikake is to repurpose other shikake.

For instance, in repurposing the basketball hoop affixed to a garbage bin, one might imagine using a soccer goal or setting up a bull's-eye target instead of using a basketball hoop.

The idea of reassembling the lid of a cardboard box to be a basketball hoop and therefore creating an attractive garbage bin out of a previously unusable box might also occur to you.

In many cases, the simplest and surest method of creating a new shikake is to modify an existing shikake. Since shikake gain their worth by solving problems, if you are not concerned with the originality of a shikake, this might be the best method to use.

The main problem with this approach is that it can require you to already be very familiar with a broad range of shikake. If you are just starting out, it is unlikely that you will have a large number of shikake examples from which to gain inspiration.

Using Similarity of Behavior

Because shikake aim to solve problems by changing people's behavior, it is also possible to think up shikake by focusing on human behavior as a starting point.

Let's think about the garbage bin shikake again. If we consider behavior that resembles the act of "throwing away" garbage, then actions such as "throwing," "putting away," "inserting," "hitting," and "falling" might occur to us. If we then imagine objects that might be freely associated with each of these actions, we may think of keywords such as:

Cast/throw: Darts, fishing line, a ball
Put away/stuff in: Dishes, collections
Insert: DVDs, air, bookmarks
Hit: Shrine fortunes, a target
Fall: Trap door, evening

The point is to take a free-association attitude toward possible keywords and to not pay too much attention to different contexts, as long as the behavior is connected.

Next, we can create shikake by combining the associated keywords with the idea of a "garbage bin." Although we are forcing these ideas together, they have a shared characteristic, since they are actions that are similar to "throwing away." Thus it becomes surprisingly easy to combine them.

For example, each of the five patterns described above can lead us to ideas for shikake:

SHIKAKE: Garbage bin + fishing
HOW IT WORKS: When you put garbage into the bin, the size and weight of the garbage are measured and out of the bin comes a print of the garbage like a *gyotaku* print (a form of Japanese printmaking in which

the characteristics of a fish are recorded by applying ink to the fish and then "printing" the fish onto paper). In addition, the size, weight, and print of the garbage can be ranked and made publicly available for increased incentive and a sense of fun.

SHIKAKE: Garbage bin + collection
HOW IT WORKS: The top of the garbage bin is broken into a grid, with each square or rectangular opening designated for different kinds of garbage. If the user hits the correct square, the garbage falls into the bin.

SHIKAKE: Garbage bin + air
HOW IT WORKS: The garbage bin expands in relation to how much garbage is put into it. This is very much the principle of the Tummy Stuffer, where the stuffed animal's stomach gets bigger as you put in more stuff.

SHIKAKE: Garbage bin + fortune teller
HOW IT WORKS: When you put garbage into the bin, a piece of paper with a fortune written on it comes out.

SHIKAKE: Garbage bin + rolling course and trap door
HOW IT WORKS: The garbage falls through a trap door and into the bin after rolling its way along the turns of a custom-built course.

The structure of these ideas is like that of a riddle: "Apply B to achieve A, which then produces the essence of the shikake C."

By connecting A (the target of the shikake, which is the garbage bin in this case) and B (the elements of the shikake, which here are "fishing," "collection," and so on), the result is C (the action being induced, which here is "throwing," "putting away," etc.). In skillfully designed shikake, A and B at first glance appear to be unrelated. In a delightful turn, C, the aspect of the shikake that connects them, then becomes visible.

The most important step in this method is listing words associated with a given behavior. However, you might become blocked when trying to think of useful words. When this happens, I like to perform an internet image search. By typing in an appropriate keyword and then thinking about the problem while staring at images that may or may not be related to it, useful ideas often occur to me.

Images can also act as stimulants that draw out associated words, concepts, and memories. I recommend this method as well because it is easy to implement.

Starting with the Principles of Shikake

It may be useful to start with first principles: in this case, the principles of shikake introduced in Chapter 2. Shikake are made up of the combination of principles chosen from among two major categories, four intermediate categories, and sixteen minor categories. For example, you might think about what sort of shikake would result from adding in a "feedback" feature.

Specifically, you can try to come up with specific ideas about providing feedback through hearing, touch, smell, taste, and sight.

"The World's Deepest Bin" is an example of a shikake that uses audio feedback. We can imagine what sort of shikake would result from using feedback based on sight, touch, smell, and taste. In this way, the following kinds of shikake ideas could be created:

SHIKAKE: Garbage bin + visual feedback (sight)
HOW IT WORKS: Make the weight or height of the

garbage in the garbage bin visible through a meter. Add a ranking function and create a competition between users or between garbage bins.

SHIKAKE: Garbage bin + haptic feedback (touch)
HOW IT WORKS: When users put garbage into the bin, a fan on top of the bin begins to blow, sending a cool breeze at the users' faces.

SHIKAKE: Garbage bin + olfactory feedback (smell)
HOW IT WORKS: A pleasant smell is released by the bin when (foul-smelling) garbage is thrown into it.

SHIKAKE: Garbage bin + gustatory feedback (taste)
HOW IT WORKS: The garbage bin "eats" the garbage, making noises and burping as if the garbage were delicious.

To create a shikake with this method, one needs only a problem to be solved and the principles of shikake shown in Figure 3.

Osborn's Checklist

If you feel stumped when trying to come up with a new shikake, it is always a good idea to try changing your point of view. Osborn's checklist, made up of the following nine questions, is recommended in such cases.

1. Put to other uses?
2. Adapt?
3. Modify?
4. Magnify?
5. Minify?
6. Substitute?
7. Rearrange?
8. Reverse?
9. Combine?

The SCAMPER method, a slight variation of the Osborn checklist, is also well known. SCAMPER is an acronym for the following seven questions:

1. Substitute?
2. Combine?

3. Adapt?

4. Modify?

5. Put to other uses?

6. Eliminate?

7. Rearrange/Reverse?

For example, if you feel stuck when thinking about shikake that would use a garbage bin, asking the "Put to other uses?" question might lead you to target a type of garbage that you had not considered, to think of situations that garbage bins have not often been used for, or to think of what else might go into a garbage bin besides garbage.

Toys in a children's room or papers in an office might occur to you as things that often lie scattered around. These should not just be thrown out like garbage, but if we examine them carefully, many of the toys or documents may no longer be needed. If we can be made to realize that things we thought were necessary are actually unnecessary, garbage is the result. The concept of a garbage bin used to clean up by producing garbage has now been born.

This is an example of the power of changing your perspective, even if only a little. The result is often a breakthrough.

However, if you do not test out various methods, you will never know whether such methods are suited to the shikake you are creating. It is best to try a variety of different methods to determine the ones that you find most effective.

The Russians Used a Pencil

"If all you have is a hammer, everything looks like a nail."[3] This statement is known as Maslow's hammer. It refers to the tendency to use the methods that we are familiar with and skilled at in every situation. When facing a problem, the more knowledgeable about technology a person is, the more likely they are to use technology. They may even attempt to apply unsuitable kinds of technology to solve simple problems in a complicated way. There is an American joke that ridicules this tendency.[4]

When NASA first started sending up astronauts, they quickly discovered that ballpoint pens would not work in zero gravity. To combat the problem, NASA scientists spent a decade and $12 billion to develop a pen that writes in zero gravity, upside down, underwater, on almost any

surface, and at temperatures ranging from below freezing to 300 degrees Celsius.

The Russians used a pencil.

I would like to emphasize that this "using a pencil" joke can tell us a lot about creating shikake. When thinking about separating garbage, a creator might dream up a garbage bin that has some sort of robotic separator attached.

However, rather than seeking a complicated technological solution to make hard work totally unnecessary, this hypothetical creator should remember that the goal is to devise something that causes people to simply want to separate their garbage.

Even if a robot could move about freely and solve certain problems on its own, humans would almost surely be better at solving the same problems. Further, convincing them to do so would almost surely be much cheaper and more efficient.

Humans can assess their environment and identify different objects in it. They can move about freely while knowing where their feet are, and they can manipulate their hands in complicated and subtle ways. These actions, which are easy for humans to do, are all difficult for a robot. As humans also possess knowledge and experience that we have

cultivated and gained throughout our lives, we are not just physically capable but excellent at making decisions about tasks in a holistic way.

In the end, machines find it difficult to accomplish sophisticated tasks, often break down, and incur large financial costs. With some exceptions—such as for dangerous jobs in places where humans cannot survive and for repetitive factory jobs—machines' disadvantages significantly outweigh their advantages.

Creators of shikake should rely on machines as little as possible and focus instead on changing human behavior. When creating shikake, it is best to always keep in mind that we might be seeing the problem as a "nail" and thereby losing sight of its true nature.

Examples of Invented Shikake

Finally, I will introduce two shikake from my seminar that were exhibited and implemented at the Shikake Lab of the 2015 Osaka University Machikane Festival.

Shikake 30 is constructed in the form of the "Mouth of Truth," made famous by the movie *Roman Holiday*. A

papier-mâché lion opens its mouth wide, making the user curious to stick their hand inside. Within the mouth is an automatic hand sanitizer. When you put your hand into the mouth, it gets sprayed with the sanitizer and cleaned. Not only did most people put their hand into the lion's mouth, but the surprised reaction of those who put their hands in drew the interest of bystanders, therefore creating a chain reaction that made the shikake a great success.

The Shikake Lab had hoped to use Classroom C407

Shikake 30. A lion hand sanitizer.

Shikake 31. Human fishing.

on the fourth floor of Building C, a location that few students come to. We made this decision because we wanted to experiment with shikake that would make people want to come to the Shikake Lab classroom.

Building C has a U shape, somewhat similar to a three-sided artificial fishing pool. Shikake 31 was created as "human fishing," an action that involved attempting to "land" people who passed by on the ground level. A piece of twine was dangled from the fourth floor with a fishing bob and a capsule containing a flyer about human fishing. People on the ground floor saw the bobs and the capsules in front of them and realized that they were being "fished for." Looking up to the fourth floor, they saw a large banner with the words "Human Fishing" hanging from the ledge. This sparked many people's interest and they ended up coming to Room C407.

This shikake was also a great success. Not only did 100 percent of the lines cast end up with people taking the bait and viewing the flyer, but many people also took the extra step of coming to room C407, where they then enjoyed the exhibits in the Shikake Lab and could do some human fishing themselves.

Conclusion

This book is the result of the research into shikakeology that I have been conducting for the past fifteen years. It has been written to appeal to a wide readership. It would be a true pleasure if this book could make others excited about the future that the use of shikake will make possible.

In the book's introduction, I discussed the impetus for beginning to work on shikakeology, but I should also mention that the risks for a researcher involved in starting up a new area of research are quite significant. The most unfortunate aspect is that no academic societies devoted to shikakeology yet exist. A lack of academic societies means that there are no opportunities to present the results of my research. Also, as there are few colleagues involved in the same research, I must make advancements in the field almost by myself. This requires considerable resolve and continued optimism.

Broadly speaking, the value of a researcher can be divided into their academic and social contributions. However, without academic conferences devoted to my field, academic contributions to shikakeology cannot be expected. My only option has been to present at conferences for affiliated fields. This is like always being the away team and is often uncomfortable.

I have been able to sponsor an annual organized session on shikakeology at the national conference of the Japanese Society for Artificial Intelligence, said to be the most liberal Japanese academic society. I am fortunate to have met colleagues through these events. In addition, motivated by the belief that it is best to provide social contributions if academic contributions are not possible, I have been working to expand shikakeology by holding events that target the general populace, such as workshops, hackathons, and contests.

I chose the term "shikakeology" because of my desire to select a name that is familiar to the general public (in Japan, at least). Many people may react to seeing a term that ends with "-ology" by keeping a respectful distance and gradually losing interest. However, I have found that many others already seem to understand and be interested in shikakeology. As a result, further research and breakthroughs are

necessary. The field will never expand merely because people show some interest after hearing a fun-sounding word.

Therefore, I have wanted to publish a book on shika-keology aimed at a general audience for some time now. The field has indeed attracted many different groups and individuals, from ordinary people to business leaders, but unfortunately there has been nothing to give to these people in terms of literature aside from academic articles (written by me). Through this book, I hope to create more opportunities for people to become familiar with this field and put shikakeology to practical use.

Notes

INTRODUCTION: SHIKAKE IN THE WILD

1. I most recently visited on June 12, 2016.
2. Matsumura et al., "Shikakeology," pp. 419–29.
3. According to the frequently asked questions on the Urinal Fly website, the optimal position is 51 mm above the drain with 25 mm on each side.
4. Thaler and Sunstein, *Nudge*.
5. The flames in the targets in the urinals at Kidzania Koshien do not disappear, but stickers with flames that disappear are sold. Also, there are blue triangle marks in the urinals of the men's bathroom in the JR Tokai bullet train station that become red when their temperature changes.
6. Wickes, "Fun Theory and the Extraordinary Power of Fun."
7. Assuming no air resistance, the depth of this garbage bin would be an incredible 300 yards!
8. Rolighetsteorin, "The world's deepest bin - Thefuntheory.com - Rolighetsteorin.se."

CHAPTER 1: THE FUNDAMENTALS OF SHIKAKE

1. Thaler and Sunstein, *Nudge.*
2. The secondary effects of shikake were first identified by Mitsunori Matsushita (Kansai University) in a tweet. Mitsunori Matsushita (M2NR) said, "I feel that shikakeology has a 'secondary effectiveness' at its base. It does not involve inducing behavior through explicit norms, such as the design of social systems and so on, but rather accomplishes a secondary effect [the prevention of scattering] by providing a different goal to the actor [a fly mark in a urinal]." M2NR, tweet.
3. The word "direct" was provided at the suggestion of Kumiyo Nakakoji (Kyoto University).
4. This example came from a conversation with Noriko Inagaki (RD Center at Kokuyo Co., Ltd.) and Akihiko Kobayashi (RD Center at Kokuyo Co., Ltd.) and has been included with permission from both of them.

CHAPTER 2: HOW SHIKAKE WORK

1. These rolls were shaped into triangles by hand.
2. This experiment was carried out in a seminar course during the 2011 academic year at Osaka University, "The Workings of Devices That Set People in Motion."
3. As of April 3, 2016, a search using *"yakiniku"* (grilled meat) as a keyword on Tablelog, a Japanese review website similar to Yelp, for the Tsurubashi area produced eighty-three hits.
4. "Projects / Necomimi," Neurowear, http://neurowear.com/projects_detail/necomimi.html.
5. Affordance does not refer to affordance as used by James Gibson in *The Ecological Approach to Visual Perception* but rather "perceived affordance" as used by Don Norman in *The Psychology of Everyday Things* and "Designing Waits That Work."

6. If a white ellipse is painted instead of a line, it is called an optical dot.

7. Cakes made with intense, striking colors are sold in some countries, but because they are common and expected in these cultures, they may be palatable to customers.

8. Schultz, "Speed Camera Lottery Wins VW Fun Theory Contest."

9. Deci, "Effects," pp. 105–15. Lepper et al., "Undermining," pp. 129–37.

10. Norman, "Designing Waits," pp. 23–28.

11. Bateson et al., "Cues of Being Watched," pp. 412–14.

12. However, it increases the incidence of theft in other places. Nette et al., "Cycle Thieves," e51738.

13. Keizer et al., "Spreading," pp. 1681–85.

14. List and Lucking-Reiley, "The Effects of Seed Money," pp. 215–33.

CHAPTER 3: HOW TO CREATE SHIKAKE

1. If you look closely, I also appear in this photograph.

2. Young, *A Technique for Producing Ideas.*

3. Maslow, *The Psychology of Science.*

4. In fact, NASA also initially used pencils. Garber, "Fisher Space Pen."

Bibliography

Bateson, Melissa, Daniel Nettle, and Gilbert Roberts. "Cues of Being Watched Enhance Cooperation in a Real-World Setting." *Biology Letters* 2, no. 3 (2006): 412–14.

Deci, E. L. "Effects of Externally Mediated Rewards on Intrinsic Motivation." *Journal of Personality and Social Psychology* 18, no. 1 (1971): 105–15.

Garber, Steve. "Fisher Space Pen." NASA, August 3, 2004, http://history.nasa.gov/spacepen.html.

Gibson, James J. *The Ecological Approach to Visual Perception.* Hove, UK: Psychology Press, 1986.

Hoshino, Tadao. *Introduction to Ways of Thinking.* 3rd ed. Tokyo: Nikkei Business Publications, 2005.

Keizer, Kees, Siegwart Lindenberg, and Linda Steg. "The Spreading of Disorder." *Science* 322 (2008): 1681–85.

Lepper, M. R., D. Greene, and R. E. Nisbett. "Undermining Children's Intrinsic Interest with Extrinsic Reward: A Test of the 'Overjustification' Hypothesis." *Journal of Personality and Social Psychology* 28, no. 1 (1973): 129–37.

List, John A., and David Lucking-Reiley. "The Effects of Seed Money and Refunds on Charitable Giving: Experimental Evidence from a University Capital Campaign." *Journal of Political Economy* 110, no. 1 (2002): 215–33.

M2NR. Tweet. Twitter. August 11, 2011, 2:23 p.m. https://twitter.com/
m2nr/status/101584511271321600.

Maslow, Abraham H. *The Psychology of Science: A Reconnaissance.* New
York: Harper & Row, 1966.

Matsumura, Naohiro, Renate Fruchter, and Larry Leifer. "Shikakeol-
ogy: Designing Triggers for Behavior Change." *AI & Society* 30, no. 4
(2015): 419–29.

Nettle, Daniel, Kenneth Nott, and Melissa Bateson. "'Cycle Thieves, We
Are Watching You': Impact of a Simple Signage Intervention Against
Bicycle Theft." *PLoS ONE* 7, no. 12 (2012): e51738.

Norman, Donald A. *The Psychology of Everyday Things.* Revised and sup-
plemented edition. Translated by Akira Okamoto, Michiaki Yasumura,
Soichiro Iga, and Hisao Nojima. Tokyo: Shinyosha, 2015.

Norman, Donald A. "Designing Waits That Work." *MIT Sloan Manage-
ment Review* 50, no. 4 (2009): 23–28.

"Projects / Necomimi." Neurowear. http://neurowear.com/projects_
detail/necomimi.html.

Rolighetsteorin. "The world's deepest bin - Thefuntheory.com - Rolighet-
steorin.se." YouTube, October 7, 2009. Video, 1:26. https://youtu.be/
cbEKAwCoCKw.

Schultz, Jonathan. "Speed Camera Lottery Wins VW Fun Theory Con-
test." *Wheels* (blog). *New York Times,* November 30, 2010. https://
wheels.blogs.nytimes.com/2010/11/30/speed-camera-lottery-wins-vw
-fun-theory-contest/.

Thaler, Richard H., and Cass R. Sunstein. *Nudge: Improving Decisions
About Health, Wealth, and Happiness.* Translated by Mami Endo.
Tokyo: Nikkei Business Publications, 2009.

Wickes, Stuart. "Fun Theory and the Extraordinary Power of Fun." *The
Family Adventure Project* (blog). November 25, 2018. https://www
.familyadventureproject.org/fun-theory/.

Young, James Webb. *A Technique for Producing Ideas.* Translated by Shi-
geo Imai. Tokyo: CCC Media House, 1988.

About the Author

Born in Osaka in 1975, **Naohiro Matsumura** graduated from the School of Engineering Science at Osaka University and received a doctorate (PhD in engineering) from the University of Tokyo Graduate School of Engineering. He has been an instructor since 2004 and an associate professor since 2007 at the Osaka University Graduate School of Economics. He was a visiting researcher at the University of Illinois at Urbana-Champaign in 2004, and a visiting researcher at Stanford University from 2012 through 2013. His pastime is playing with his daughters.